IMAGES
of America

MINING CAMPS OF
PLACER COUNTY

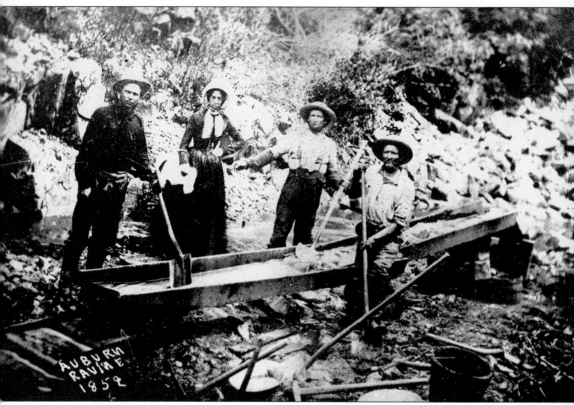

Three men and a woman work the sluice in Auburn Ravine near present-day Old Town Auburn. F.H.H. Fellows reported the following in the *Placer County Republican* after the devastating fire of 1855:

> Mrs. Eliza Elliott, the proprietress of the Orleans Hotel, had a drove of 20 hogs that were called the scavengers of the town. These hogs were bred and kept in a big pen back of, and near her hotel and as the town was not incorporated and as there was no law against the hogs wandering about the streets and basking and sleeping in the sun on the sidewalks, and no one seemed to care a damn about these hogs as they had become used to them from away back and considered them apart of the town, and the town would not look natural without the hogs. So the hogs run the town, and Mrs. Elliott was mayor because she owned the hogs and as no one was brave enough to make a complaint, this state of affairs went on up to the time of this fire. The morning after the fire there was enough roasted hog meat to supply the whole county with roast hog for at least one meal.

The 1850 census of the Auburn-Foresthill area of Sutter County lists 34 women and approximately 2,910 men. By 1852, 340 women and 6,829 men were listed. One-third of the women were with families, 6 listed occupations such as cook, and 14 were listed as prostitutes. Approximately one-third of the women were listed alone, and another 60 were listed with their husbands and no children.

IMAGES
of America

MINING CAMPS OF PLACER COUNTY

Carmel Barry Schweyer
and Alycia S. Alvarez

ARCADIA

Published by Arcadia Publishing
Charleston SC, Chicago IL, Portsmouth NH, San Francisco CA

Printed in Great Britain

Library of Congress Catalog Card Number: 2004111078

For all general information contact Arcadia Publishing at:
Telephone 843-853-2070
Fax 843-853-0044
E-mail sales@arcadiapublishing.com
For customer service and orders:
Toll-Free 1-888-313-2665

Visit us on the internet at http://www.arcadiapublishing.com

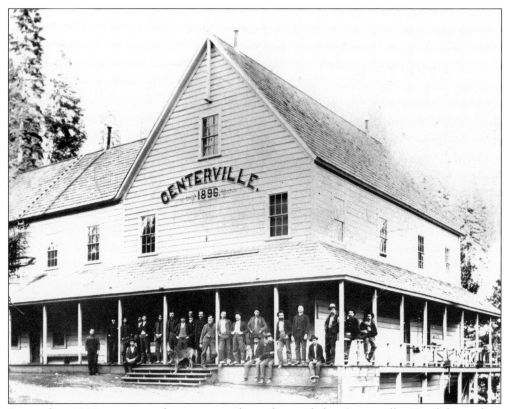

Pictured c. 1900, a group of miners stands in front of the Centerville Hotel located in Centerville (renamed Bullion in 1904) on the Foresthill Divide.

CONTENTS

ACKNOWLEDGMENTS

The authors would like to thank Helen Charles, Doug Ferrier, and Bob and Sharon Balmain for their research assistance. The photographs in this book are courtesy of the Placer County Department of Museums, the Sadie Burt Howell Estate Collection, and Carmel Barry-Schweyer.

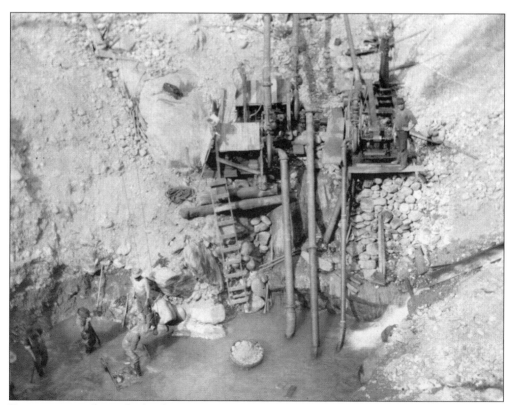

Four miners work in a hydraulic mining operation.

INTRODUCTION

On January 24, 1848, James Marshall discovered a small piece of gold in the millrace of the sawmill owned by John Sutter, just a few miles from what would become Placer County. However, the news of the discovery did not reach the newspapers in the East for almost a year. Meanwhile the news sent shockwaves through the settlements along the coast of California and Oregon. Gold seekers from these settlements came to the Coloma area to find their fortunes in the spring of 1848.

Claude Chana is credited with the first gold discovery in Placer County near present-day Auburn. He came to California in 1846 and worked on the Sicard Rancho on the Bear River. While crossing through Placer County to Coloma in 1848, Chana made his gold discovery in the Auburn Ravine. Chana achieved success in mining and purchased Sicard's Ranch to pursue a career in agriculture.

On December 5, 1848, President Polk confirmed the story of gold discovered in California. Gold! Free for the taking! Why, you could just pick it up by the bucketsful! Fortune hunters from Canada, the Northeastern states, Southern states, the Western frontier and the rest of the world rushed to California to find their share of gold.

When gold fever struck North America, doctors, lawyers, merchants, farmers, and laborers alike dropped their work and headed for California. The migration to California touched all ethnic, religious, cultural, and political groups.

The thousands of gold seekers who poured into Placer County brought with them a variety of values, traditions, and ideals, some of which they kept; others were discarded and replaced with new. Some stayed and settled in the new land; most went back home or moved on to the Frasier River and Nevada gold and silver mines.

By spring of 1849, mining camps popped up along rivers and streams throughout Placer County and the Sierra Nevada foothills. Scores of mining camps with colorful names like Condemned Bar, Granite Bar, Horseshoe Bar, Deadman's Bar, Rattlesnake Bar, Whiskey Bar, Murderer's Bar, Poverty Bar, and Humbug Bar were located along the American River.

Early miners used wooden bowls called bateas, then metal pans, rockers, Long Toms, and sluices to extract the gold from the streams. As gold became more difficult to find, other methods of extraction were developed such as drift, hard rock (also known as quartz and lode), and hydraulic mining. These were large operations and required a considerable amount of money to run. Investors from faraway San Francisco, New York, and England owned stock in local mining companies.

As gold panned out along the rivers, miners moved up the canyons and hillsides in their insatiable thirst for riches. Miners established settlements near the camps on higher ground. Forest Hill, Dutch Flat, Iowa Hill, Gold Run, Sunny South, Bullion, Damascus, Illinoistown, Yankee Jim's, Michigan Bluff, and Ophir were just a few of the towns established high above the rivers.

Hydraulic mining began in Placer County at Yankee Jim's in 1852 and was employed extensively. This method of mining used huge nozzles that sprayed powerful streams of water,

washing away entire mountains. Tons of mud and debris washed downstream, filling rivers and streams, ruining farmlands and waterways in the valleys below. Judge Lorenzo Sawyer prohibited the dumping of the debris into the Sacramento and San Joaquin Rivers as well as their tributaries in 1884, a crushing blow for hydraulic mining. In 1893, the Caminetti Act allowed hydraulic miners to operate if the debris could be caught in dams. Lake Clementine, near Auburn, is the result of one of these dams. Hydraulic mining continued in Placer County at the Pacific Slab Mine in Last Chance on the Foresthill Divide until the 1970s—one of the last operating hydraulic mines in the country.

As mining changed from a single man, or a small group activity, to large-scale operations employing many men, stable towns with churches and schools replaced the earlier temporary tent camps. Many who came to seek their fortunes in gold soon relied on skills brought from home such as agriculture, merchandising, teaching, banking, and law to make a living.

Many who came in search of gold established businesses, planted fruit and vegetables, and continued to work their claims. As the difficulty of extracting gold increased, agriculture began to grow in importance, especially in the foothill and valley locations. The logging and ice industries also grew in importance as towns replaced mining camps and trading centers.

When the Central Pacific Railroad constructed the western portion of the first transcontinental line through Placer County in the mid-1860s, the agriculture, clay, and granite quarry industries expanded. The towns of Roseville, Rocklin, Loomis, Penryn, Newcastle, Auburn, and Colfax, all located along the Central Pacific line, became important shipping centers for the agriculture and quarry industries.

Although mining dwindled through the turn of the century, with a slight resurgence of placer mining along the rivers during the Depression, it continued to support the economy of the towns, especially on the Foresthill Divide. Mining operations continued in Placer County until World War II, when the majority of mines in California closed down never to regain their importance.

Miners prepare to unload an ore car at the stamp mill.

One
GETTING THERE

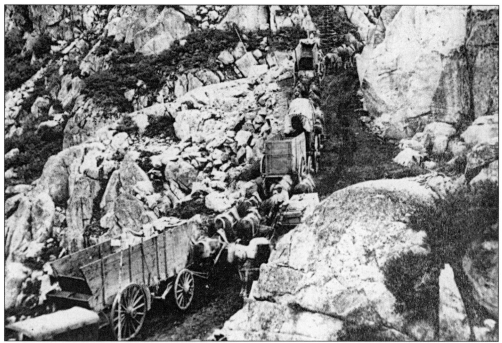

Wakeman Bryarly noted in his diary when crossing the Sierra Nevada, "If I had not seen the wagon tracks marked upon the rocks, I should not have known where the road was, not [sic] could I have imagined that any wagon and team could possibly pass over in safety." The greatest number of immigrants to come to California during the Gold Rush came overland by foot, wagon, or horseback. Over 25,000 49ers traveled the California Trail, the principal route. These people faced potential problems of Indian attacks, accidents, and cholera. Crossing the plains to the Sierra Nevada generally took the entire spring and summer with a final rush over the mountains to beat the snow. The number of overland immigrants to California in 1848 totaled approximately 400. The following year, after the announcement of the gold discovery, 25,000 traveled to California overland. The number totaled 44,000 in 1850, but the next year the number dropped to 10,000. There was a resurgence of 50,000 in 1852 that dropped to a meager 20,000 the succeeding year. Numbers decreased again to 1,500 in 1855; however, emigration rose to 8,000 the following year.

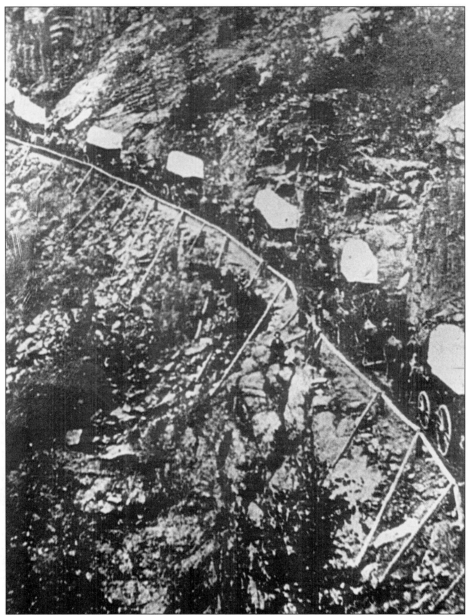

Isaac Wister reported in his diary: "[On the] hundred and eleventh day out, the whole day has been employed in the hardest labor, dragging the wagons over rocky ledges, and hoisting and lowering them over 'jump-offs.' Without knowing what might be at the bottom, we undertook to get the wagons down over the huge boulders which choked the gorge." Immigrants cited a variety of reasons for going West: the hope of acquiring land, to improve their health, to practice religious freedom, to flee the increasingly uncomfortable passions regarding slavery and the plight of the Negro, to escape the restraints of society, to evade the law, to evade missionary work. Before the Gold Rush, California was described as a "utopia," "promised land," "Eden," and "paradise." Residents of the Eastern states and territories harbored this notion of a utopian California that continued long after the Gold Rush. The possibility of finding gold seemed to promise a better life.

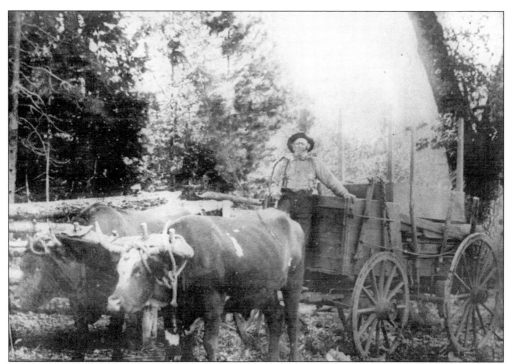

Pictured here is Bob Welch, a pioneer, with his oxen and wagon. He was reportedly one of the rescuers of the ill-fated Donner Party that was stranded in the Sierra Nevada during the winter of 1846. Sent from Sutter's Fort, he took food and supplies and to brought those who were strong enough to travel back to the fort.

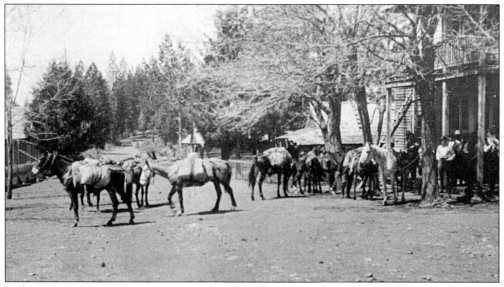

Early trails to the mines were soon widened for freight, mail, and passenger service. To reach the Foresthill Divide from Auburn, a wagon would ride from Junction House, now the Foresthill exit on Interstate 80, snake down the canyon to a ferry that crossed the river near Kelley's Bar, then wind its way up the other side of the canyon. A pack train in the 1860s is pictured at Last Chance in front of the hotel.

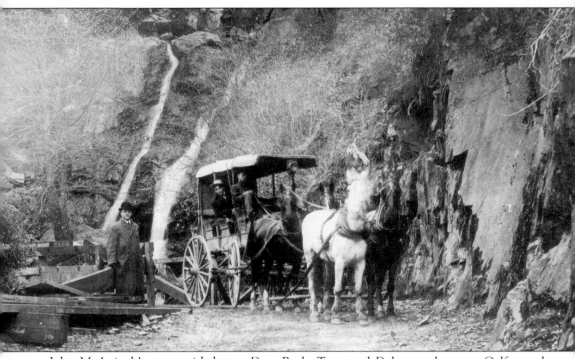

John McAninch's stage, with horses Dan, Beck, Tom, and Duke, ran between Colfax and Foresthill. McAninch was born in Antrim County, Ireland, and came to California when he was 15 years old. He first partnered with William Rea in 1878 carrying passengers, mail, and the Wells Fargo Express on the stage between Auburn and Foresthill and Michigan Bluff, adding the line to Colfax in 1879.

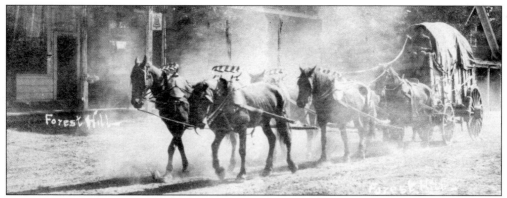

Miners and teamsters had to pay tolls for roads, bridges, and ferries. On the road to Foresthill a toll was paid at the ferry and later at the covered bridge, Grizzly Bear House, Mile Hill, Carlson's U.S. House, and Bunker's above Michigan Bluff. Prices in 1858 at Mile Hill were: 6 animals and wagon—$1.75; 4 animals and wagon—$1.50; 2 animals and wagon—$1; horses and loose animals—25¢ each. The team pictured here is seen leaving Foresthill.

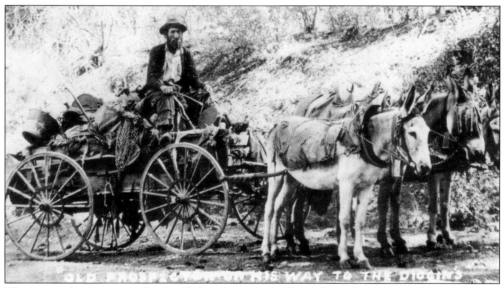

Wagon roads were carved out of sheer canyon walls with nothing more than picks and shovels. Roads were constructed by the fall of 1849 from Auburn to the Bear River and Illinoistown, now Colfax. To reach Kelley's Bar on the North Fork of the American River teamsters lowered their wagons by ropes with log drags to slow them down on the steep canyon in the spring of 1850.

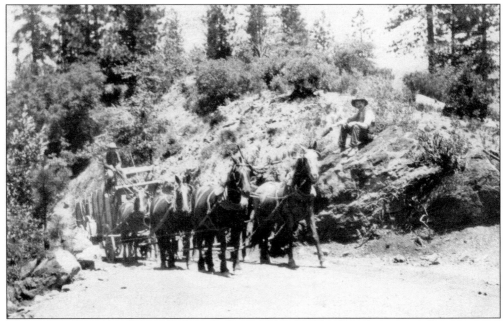

Teamster Ling Ying and Forster Williams, on the bank, are pictured above the Red Ledge Mine on the Foresthill Divide. Early teamsters used any cart or wagon available; however, by the mid-1850s wagons designed for the mountains were used. Mountain wagons were made of pine and shaped like a "bread dough trough." They could carry 9,500 pounds and weighed 3,800 pounds empty and usually required a six-mule team to haul them.

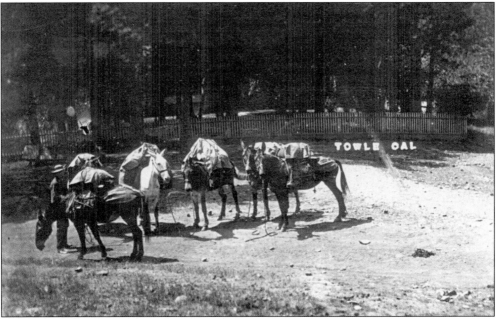

Pack mules delivered supplies and mail to remote mines and mining camps. Packers camped in clearings and meadows that provided water and food for the mules. Often these camping spots became way stations as wagon roads were developed. This team is pictured in the logging town of Towle near Dutch Flat.

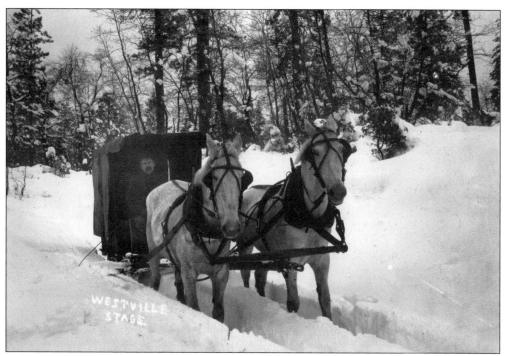

Snow up to the horses' knees and the axle of the stage at Westville in the winter was not unusual. The stage was a sled in wintertime, with side curtains to protect passengers from inclement weather.

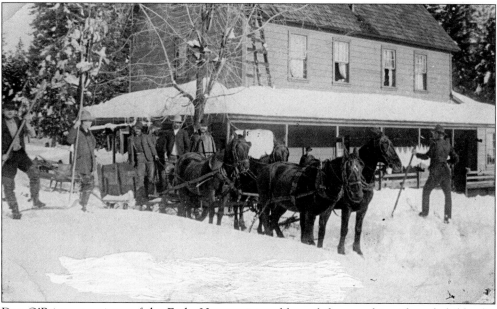

Dan O'Brien, proprietor of the Forks House, pictured here, left to see his wife and child, who were staying at her sister's house in Bath for the winter. He was found in the snow, shot in the head, with his rifle by his side. The newspaper reported that he was, "a typical mountain man, generous and hospitable, and popular with all." He came to Placer County from Canada and married Christina Liddle, born in Grizzly in 1861, at Sunny South in February 1884.

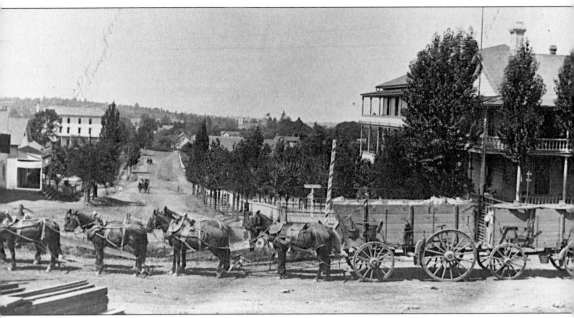

John Conroy drove the team from the Mountain Quarry lime diggings, pictured here with a load of limestone. The Putnam Hotel is the large building between the trees on the left, and the Freeman Hotel is on the right. A sign by the barber pole in front of the Freeman Hotel advertises a shaving saloon, while William Freeman drives the buggy up Railroad Avenue (now Lincoln Way). This was photographed in 1886 when roads were developed and a wagonload of supplies could make it to Foresthill or Dutch Flat in a day or two. Since the summer of 1850 the road from Auburn to Foresthill had been opened for wagon traffic. Way stations were located at Liberty House, Grizzly Bear House, Butcher Ranch, Mile Hill, Carlson's U.S. House, and Spring Garden, before reaching Yankee Jim's, Foresthill, and beyond. Pack mule trains hauled supplies to mining camps beyond Foresthill. The Illinoistown Turnpike from Auburn to present-day Colfax, with its string of way stations, was a good wagon road all the way to Dutch Flat by the mid-1850s.

Two
MINES

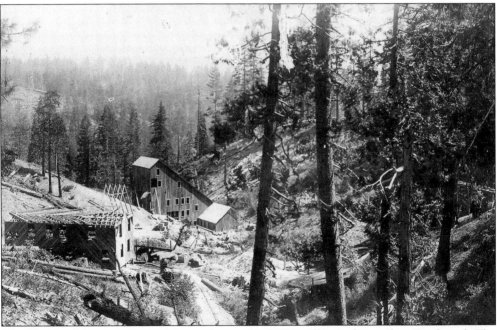

The Herman Mine was located five miles south of Westville on the road to Deadwood. The hoist house for the mine is seen here at center left. The total yield was over $200,000 with ore that produced $4 to $4.50 a ton. The boarding house at the mine was 24 by 48 feet and accommodated 30 men. The *Placer Herald* newspaper reported that the boarding house was "one of the largest in the State and is provided with a reading room and a bath room. No expense has been spared in making this building a pleasant house for the men during their rest hours. The company has its own store, but is reasonable in its prices. A good table is set in the boarding house and no one need hunger." In September of 1895, a storeroom and office were added to the boarding house, and there were smaller cabins to house men with families. They stocked 600 cords of wood, four feet long, to provide for the winter months.

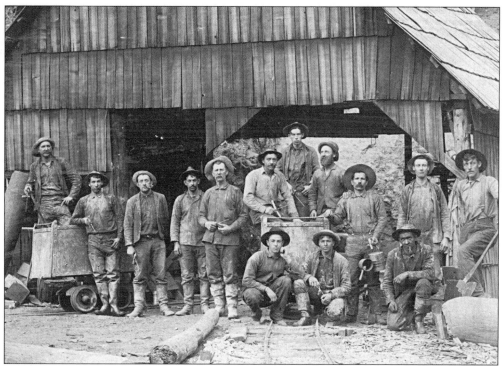

Pictured is the crew of the Herman Mine. Formerly known as the Osborne Mine and also known as the Barton Mine, it was the only extensively operated quartz mine on the Foresthill Divide. It had a 20-stamp mill in 1895, and the mine and mill ran full time.

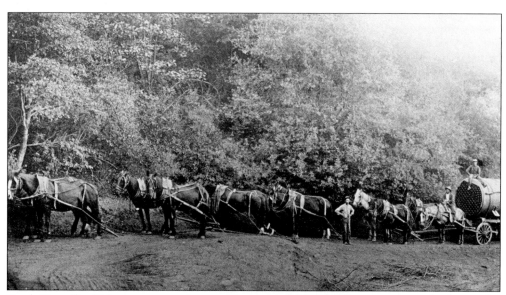

Hank Russell's 12-horse team and wagon is pictured here hauling a nine-ton boiler to the Herman Mine. Between May and August, Armstrong and Russell hauled over 160 tons of equipment and supplies to the Herman Mine. They hauled two more boilers, an engine, and machinery that filled three cars the following week.

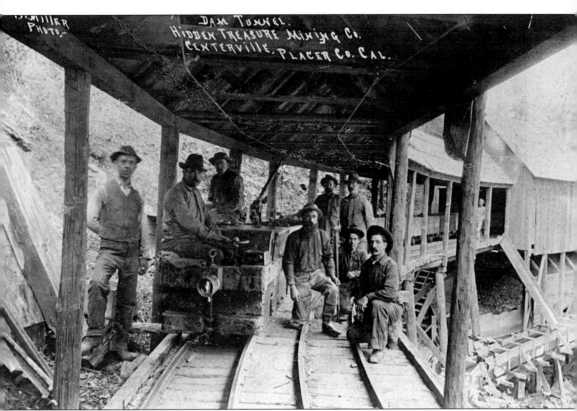

The Hidden Treasure Mining Company dam tunnel was located at Centerville (later named Bullion) and was the first mine in Placer County to have electricity. Even the locomotive was electrically powered and hauled gravel trains of 15 to 30 carloads. Note the power lines in the rafters of the snow shed and the pole from the motorcar up to the line. Water pressure under the 850-foot head generated the electricity. The mine, first discovered in 1875 by William Cameron, was the largest producing drift mine in the state. It became a model of drift mining with its improvements and low production costs. In 1889–1990, a crew of 120 men mined and washed 275 one-ton carloads of gravel in 24 hours. The crew was two-thirds Chinese, who were paid $1.75 per day while the white miners were paid $3.

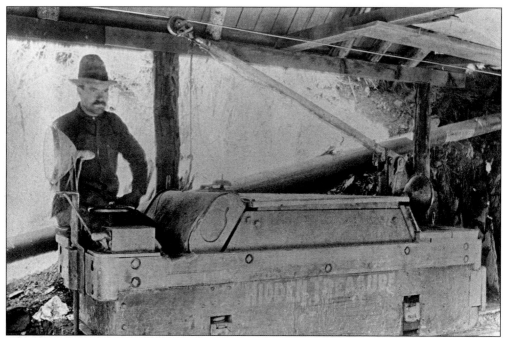

Pictured here is the motorman and electric locomotive or motorcar of the Hidden Treasure Mine. The electric lines and lights on both ends of the locomotive are clearly visible. The mine and the mining camp of Sunny South both had electricity in 1882.

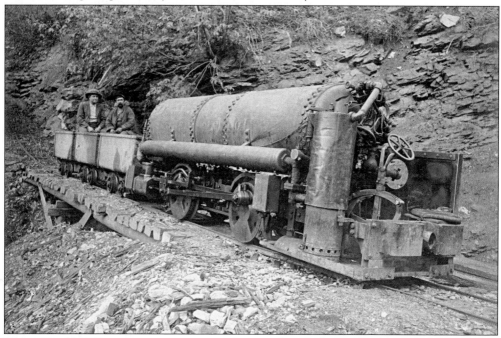

Young Harold T. Power sits in an ore car with an unidentified man. This compressed air engine pulled ore cars in the Hidden Treasure Mine. Harold was born in Sunny South in 1857 to Michael Harold and Isaline M. Keysner Develey Power. Michael, a successful investor in the Mountain Gate Mine, later became interested in the Hidden Treasure Mine.

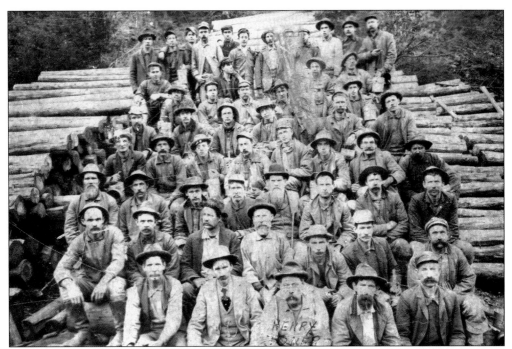

The crew of the Bullion and Hidden Treasure Mine pose for a picture in the 1890s. Henry Jones in the front center is the only man identified. Large numbers of miners were needed to work the mines. Gold-bearing gravels were shoveled into handcars, removed from the mine, and washed in long systems of sluice boxes.

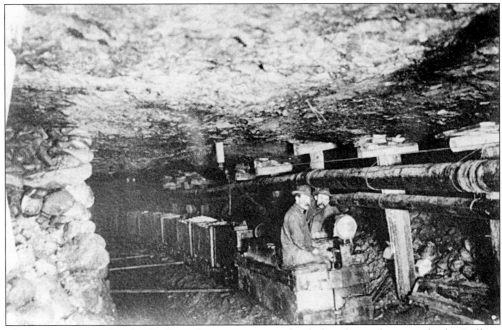

The motorman guides the Collins electric motorcar, loaded with ore from inside the Bullion Mine. Cemented ore was hauled out of the mine, crushed by stamp mills, and run through sluices to remove all of the gold.

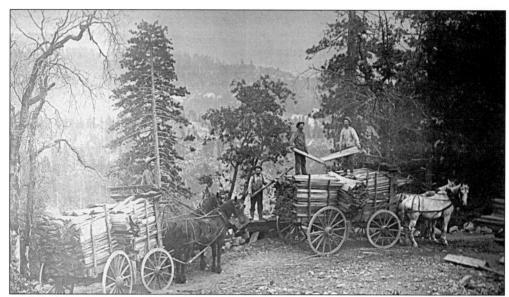

Lumber was an important component of mining and served a number of purposes, to shore up tunnels, as cord wood for steam boilers, and as lumber for buildings. Bill Henning, on the wagon at left, is hauling three and one-half foot sugarpine shingles from the Chicken Hawk area of Foresthill Divide to the Hidden Treasure Mine in Sunny South. William Banbrock, the photographer, born in Bath on the Foresthill Divide, was the son of a miner. William learned photography in Nevada when his father went there to work in the mines.

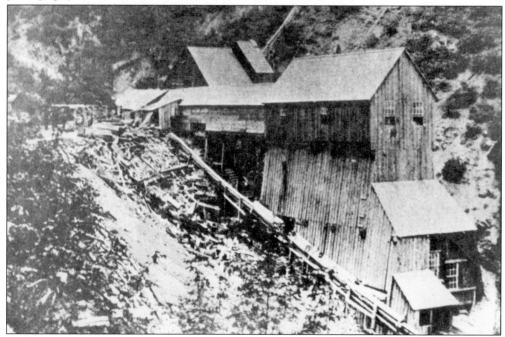

The Red Point Mine stamp mill, located in the southwest corner of Humbug Canyon, employed 50 men in 1890. The 4,000 feet of tunnel cost $12.40 per running foot. The company constructed a boarding house, office and dwelling, blacksmith shop, stable, powder house, woodshed, framing shed, and snow sheds at the site.

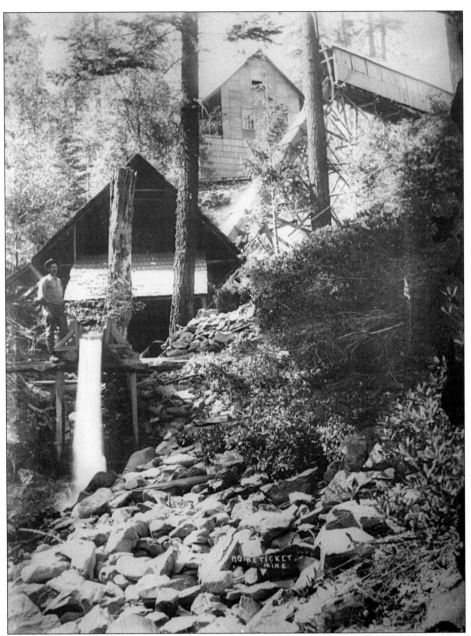

The Home Ticket Mine, located in the Last Chance area, was first worked between 1855 and 1860 and had a tunnel nearly 5,000 feet long by the 1930s. William Davis developed the mine after his years of working in the El Dorado and Paragon mines. He was superintendent of several Last Chance mines and engineer for the Pacific Slab Consolidated Mining Company. The Home Ticket Mine produced about $200,000 by the 1920s. Other notable mines in the Last Chance district included the Beaman Ledge, Bear Wallow, Central, Darling, Deep Canyon, Double O, El Dorado, Elkhorn, Golden Riffle, Grizzly, Harkness, Hornby, Last Chance, Little Hope, Missouri Flat, New Caledonia, Pacific, Pacific Slab, Peters, Rattlesnake, Rublin, Sharp Stick, and Star Town. The mines in this district were worked steadily from the 1850s until 1920.

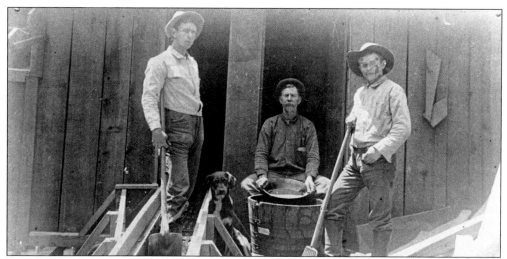

Shown here, from left to right, are 19-year-old Sam Jarvis, a dog, foreman Shell Lee, and Mike, the timekeeper and bookkeeper for the Jarvis Mine. They stand in front of the dump house, *c.* 1900. A sluice box is in front of Sam and the dog while Lee washes ore gravel from the tunnel.

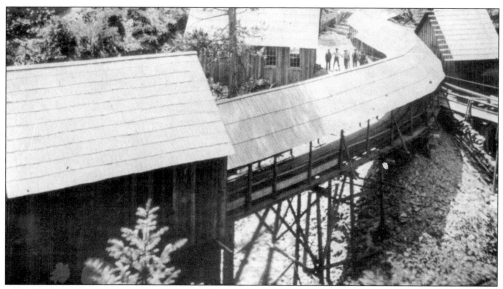

The Jarvis Mine was located between Red Point and Damascus and the area north of Forks House. The structures, from left to right, are the dump house, the trestle to the tunnel, the blacksmith shop (left of the trestle), and the tool house (right of the trestle).

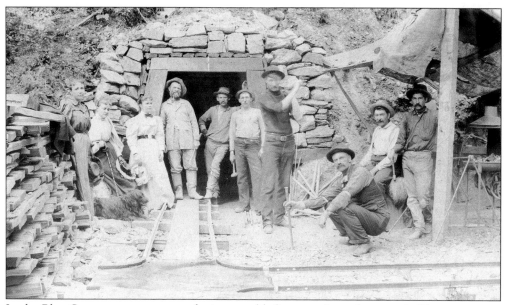

In the Blue Canyon area, a group of miners and ladies pose for a photograph. The two miners in the foreground (one crouching and one in center with a hammer over his shoulder) are demonstrating "double-jacking." The crouching man holds and turns the drill while the other miner hits it with a 12-pound hammer. The three ladies on the left with hats and gloved hands look on. The blacksmith's tools can be seen set up on the far right.

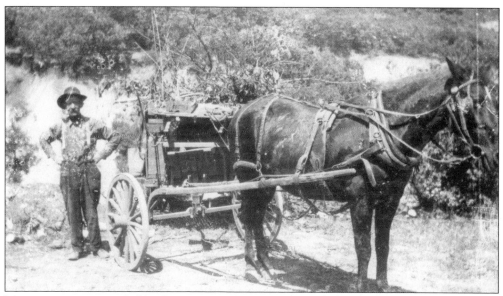

Most prospectors traveled by foot to new "diggins" when old "diggins" were panned out. This miner used a horse and two-wheeled cart. Miners were typically between 20 and 35 years old and swarmed like locusts from one location to the next as old diggings panned out and new ones were discovered.

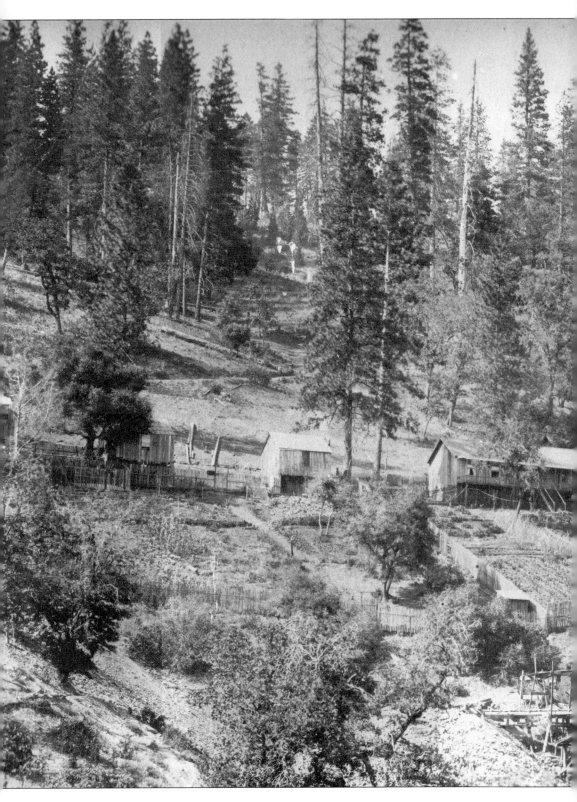

The Dardanelles Mine, opened in 1853, was originally a drift mine and was later hydraulicked. By 1889, 3,630,000 cubic yards were washed from the hillside, yielding an average of 13¢ a yard. The bank was on average 150 feet high. A five-stamp mill was installed in 1888 to crush the gravel. A stamp mill consists of a wheel and cam attached to a rod with a heavy steel shoe (stamp) that crushes ore. Stamp mills were commonly built in sets of two to five stamps, depending on the size of the mine operation. The hoist, pump, and lights were electrically powered. Few production records are available for the period between 1882 and 1894 as the company was involved in litigation during that time. The cemented, gold-bearing gravel was in a channel 5 feet high and 75 feet wide.

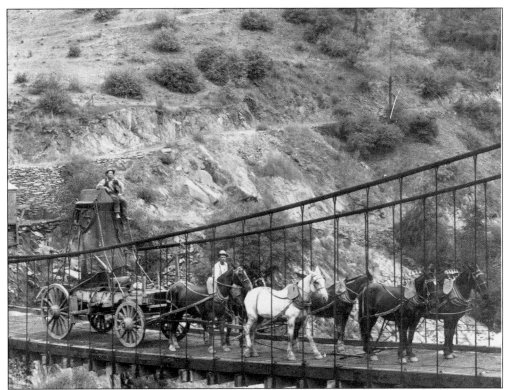

Early on, wagon roads and bridges across rivers and streams were constructed both for hauling supplies for the miners and for hauling equipment to the mines. Building roads up and down the canyons required cutting into the sides of the canyons and filling in low areas such as the rock fill, shown to the left of the boiler. Miners often earned extra money by working on roads and water ditches. Will Patrick is pictured here wearing a white shirt and sitting on a mule.

Large mining operations had blacksmiths to keep the tools and equipment in working order and to make new tools. This blacksmith shop was part of the Paragon Mine located at the mining town of Bath on Foresthill Divide.

Two miners are pictured using a rocker and a pan—a method used by early miners and small mining operations—near Burnett Lumber Mill, approximately 10 miles southwest of Emigrant Gap. As gold became more difficult to find, large mining companies formed with investors from San Francisco, New York, and London that began extensive quartz (also called hardrock or lode) and hydraulic mines. Many miners became employees of these large companies.

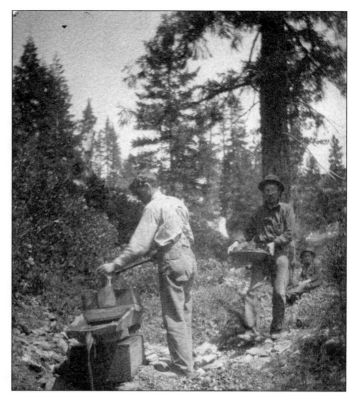

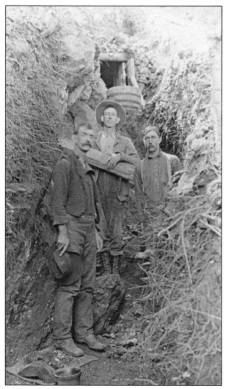

The Williams boys and ? Cole pose in front of the Red Ledge Mine located on the Foresthill Divide. They reportedly extracted $5,000 worth of gold from this mine.

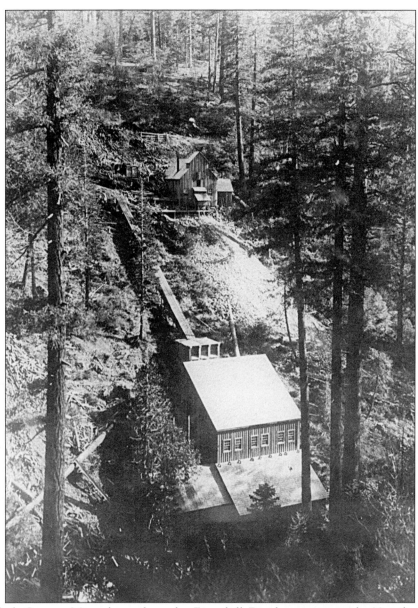

The Black Canyon Mine, located on the Foresthill Divide approximately 30 miles east of Auburn, had a 20-stamp mill with a capacity of 50 tons of ore per day. The complex included a shop, 26-room bunkhouse, large dining room, and an office. This mine was a drift mine as were many in the Foresthill Divide region. The post and cap method (two vertical timbers supporting a horizontal timber across the top of a tunnel), used in most quartz mines, did not work with the loose gravel in drift mines. Philip Deidesheimer, a mining engineer, came from Germany to the American River near Rucky Chucky Slide in 1849. He discovered the Fair View Garden claim, also known as Deidesheimer Gardens, "under the hill" at Foresthill. To shore up the unstable tunnels he used a system of "square sets." He framed timbers together in cubes, which could be piled to any height and supported and braced the rock in all directions. He became famous for this system when he applied it at the Ophir Mine in the Comstock mines of Nevada.

Three

HYDRAULIC MINING

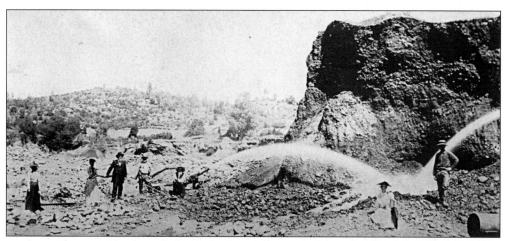

By the 1860s, as gold in riverbeds and ravines was exhausted, miners formed hydraulic mining companies to work the tertiary gravels. As hillsides were washed away, gold was gleaned from the mud and water in long sluice boxes placed in ravines. Then the debris was returned to the rivers and streams below the mines. Pictured here is Maurice A. Kelly's hydraulic mine at Rattlesnake Bar in the 1870s. Maurice is third from left and Bill Latherly, foreman, is next to him. The town of Rattlesnake was located on a flat on the North Fork tributary of the American River near Manhattan, Horseshoe, and Rattlesnake Bars approximately seven miles southwest of Auburn. John C. Barnett & Company discovered gold in the flat in the spring of 1853. The diggings were so rich that by that summer a stage line was running daily from Auburn to Rattlesnake. Stores and residences were constructed and gardens, orchards, and vineyards quickly planted. Later, the Rattlesnake vicinity would become an important agricultural region until the waters of Folsom Lake flooded it in the 1950s, after the dam was built.

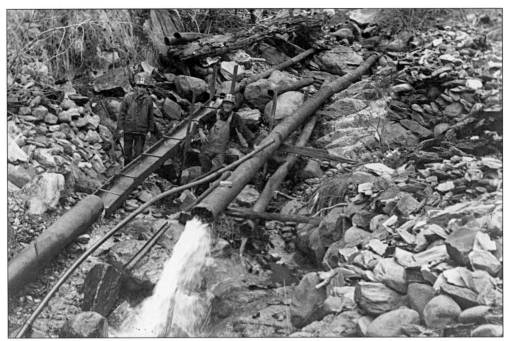

Two miners work the sluice box in Bullion Canyon on the Foresthill Divide. The sluice box has bars across the bottom called riffles that catch the heavy gold while the water washes the lighter sand and gravel down the sluice and back into the creek.

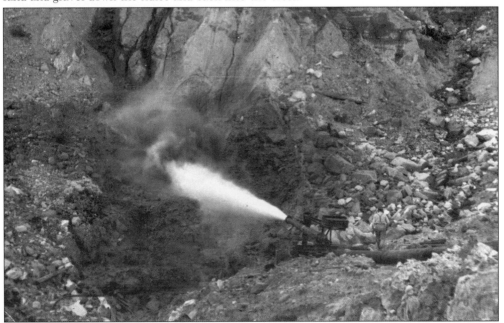

The mining companies needed large quantities of water to work the diggings. The larger companies built long ditches from rivers and headwaters in the high country to the diggings below. They sold water to smaller companies in addition to their own supply. The Paragon Mine near Bath on the Foresthill Divide, a large mining operation, sold water to other mines along their ditch system.

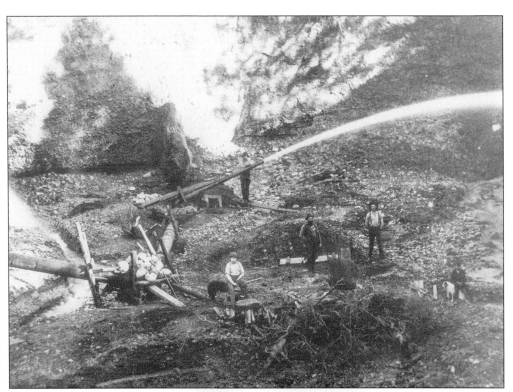

Michigan Bluff on the Foresthill Divide was the site of major hydraulic mining operations. The town, originally called Michigan City, was situated on the hillside that was being washed away for gold. The citizens moved the town up on the bluff and it became known as Michigan Bluff.

The price of lumber for flumes was high—$100 per 1,000 board feet. Poor engineering, such as constructing wooden flumes where ditches should have been used and high flumes across ravines that were costly and often blew over from the winds, resulted in declining value or abandonment of the ditches. This flume, located approximately one mile from Butcher Ranch, between Auburn and Foresthill, later collapsed and was then burned.

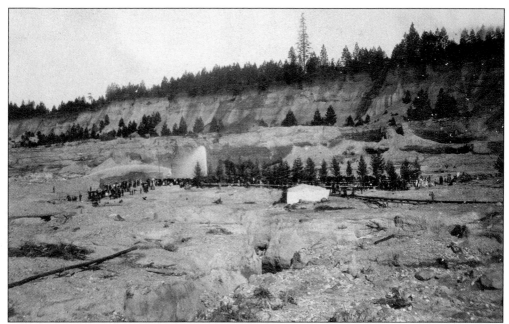

The townspeople of Gold Run gather to watch two monitors spray water in the center of the photo. The line that runs horizontally just beneath the lower row of trees is the penstock, or pipeline, that feeds the monitors. Today Interstate 80 is located along the base of the cliffs in the background.

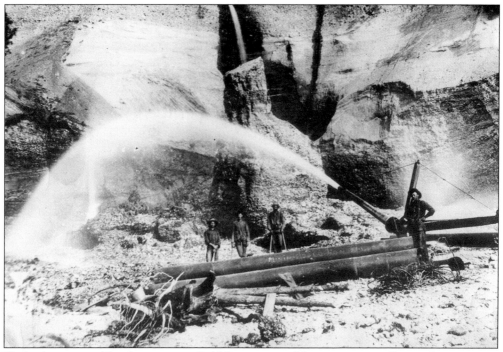

Hydraulic mining, like this one near Gold Run, required few men to actually run the operation but a great investment in constructing ditches, flumes, and reservoirs. When hydraulic mining ended, many of the water systems were taken over by power companies and irrigation districts.

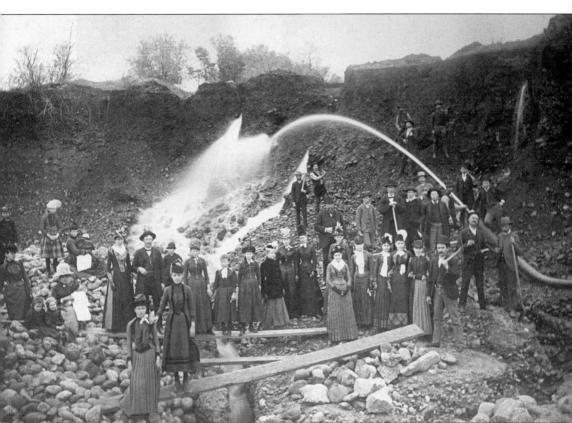

Maurice Kelley, at his diggings in Rattlesnake Bar, is pictured at center right, under the arch of the water, wearing a black hat and coat and resting his hands on a shovel. In front of Maurice are his female relatives with white plumes in their hats. From left to right are Alice, Lillian, Nora (Honie), and Annis Kelley. A tour of the mines by investors, family members, and prominent local citizens, all dressed in their finest, was an exciting outing. The women, many with hats and gloves, and the men, with their vests and watch chains, pose with picks and shovels. Maurice Kelley was born at Manhattan Bar in 1855. His father, Michael, came to Manhattan Bar in 1851, where Michael's cousin Joseph Kelley had already settled. Michael had a hotel and store in Manhattan Bar and then moved to Rattlesnake Bar in 1862. He was a miner and rancher there until his death in 1900.

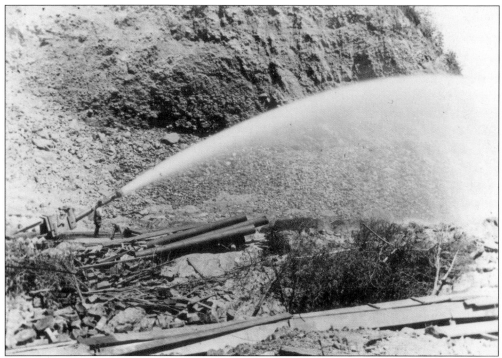

Giant monitors washed away hillsides causing the runoff of gravel, silt, and debris, called slickens, that clogged the streams and rivers below. The ranchers in the valley brought lawsuits that eventually resulted in the demise of hydraulic mining in the mid-1880s.

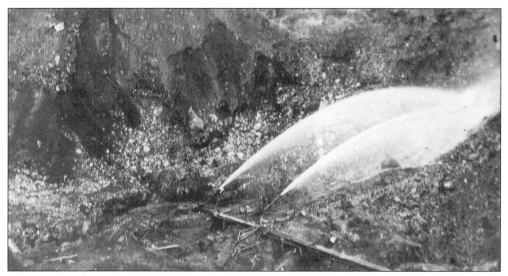

At the peak of hydraulic mining, there were 425 operations in California. Between 1895 and 1901, over 1 million cubic yards of debris were dumped into the tributaries of the Sacramento River, and silt was carried as far as the San Francisco Bay.

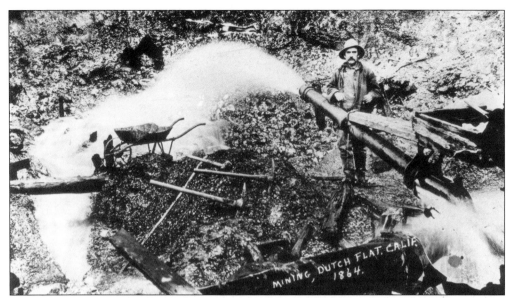

Another major area for hydraulic mining was the Dutch Flat area, approximately 30 miles east of Auburn near Interstate 80. Here a miner operates a monitor (water cannon) at the Gold Nugget Mine at Lowell Hill. Water for mining was sold by the "miners' inch," which was equivalent to 11.22 gallons per minute. In 1857, Placer County claimed a total length of 325 miles of mining ditches that cost $1.5 million and had an assessed value of $399,100. In 1858, 35 ditches comprised 550 miles at a cost of $1.55 million. Initially many water companies sold water to mines along the ditch route. As time went on and mining declined, they extended the ditches to the lower areas of the foothills and sold water to the developing fruit industry. By 1900, hydroelectric power generation was another major consumer of water.

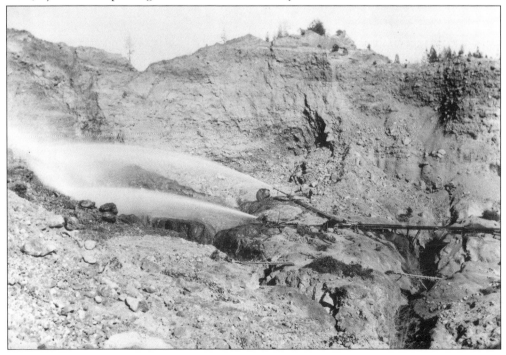

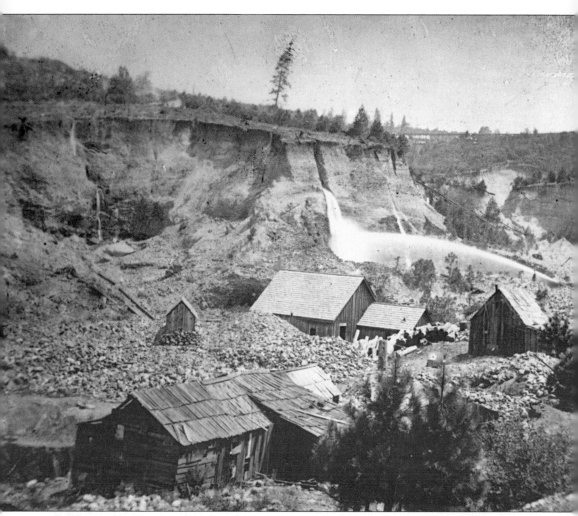

This hydraulic operation depicts the enormity of damage done to the landscape by this method of mining. The force of the water and the enormous swath cut in the mountainside is obvious. Note the scar on the landscape in the distant top right. A huge pile of logs is stacked to the right of the house in the center, probably washed from the mountain and salvaged for lumber and cord wood. The Sawyer Decision in 1884 was a deathblow to hydraulic mining. Most of the huge mining companies closed down and abandoned or lost their claims. A few companies were able to continue to sell water from the ditches to the newly developed fruit industry and hydroelectric companies. Most of the hundreds of miles of ditches in Placer County are now abandoned or have been obliterated by logging and other modern activities. The remnants of these diggings and ditches stand as testaments to 19th-century mining ingenuity and are part of Placer County's rich gold mining heritage.

Four
MINING CAMPS

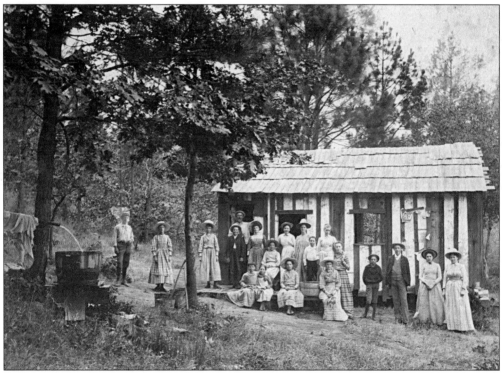

Seen here is an old miner's cabin picnic in 1891. Pictured from left to right are the following: (first row) Lil Davis Ramage, Clara Sharp, Clara Louise Fitch, and Mattie Hamilton Shepard; (second row) Jessie Fitch Bell, Frank Fitch, and Violet Soule; (third row) Howard Davis, Ethel Sharp, Mary Hamilton Wallace, Charlie Fitch, ? Moliere, Eliza Gray, Jenny McCarthy, unidentified, Victor Moliere, Fred Fitch, Gerty Norton, and Clara Finley Sharp; (fourth row) an unidentified miner.

Jessie and Lori Fitch join an old miner and his dog at his cabin. Outings to mines and other important local sites were held annually in Placer County. Yearly outings to Michigan Bluff and the Stanford Store, the Placer County Big Trees, and pioneer reunions at mines and mining camps were common. Pioneer families that moved to San Francisco, Oakland, and Berkeley were especially enthusiastic about returning to their old domains.

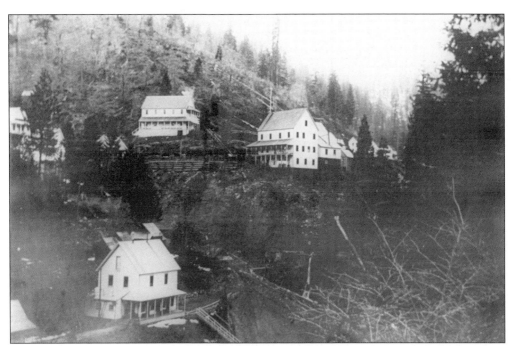

The mining camp of Bullion on the Foresthill Divide, 18 miles east of Foresthill, developed around the Bullion Mine where the miners first tunneled in from the Damascus Mine to the Sunny South Mine.

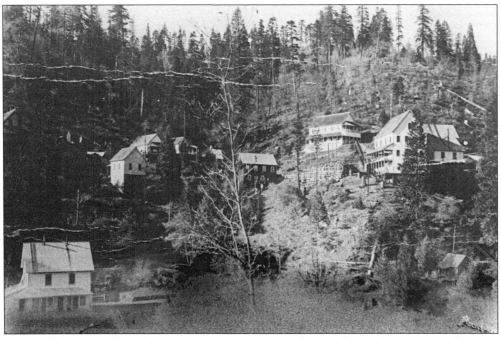

First called Centerville, the town's name was changed to Bullion when a post office was established in 1896. Bullion, once the headquarters for the Hidden Treasure Mine, had a population of 300. The headquarters moved to Sunny South, and by 1906 there were only 10 registered voters.

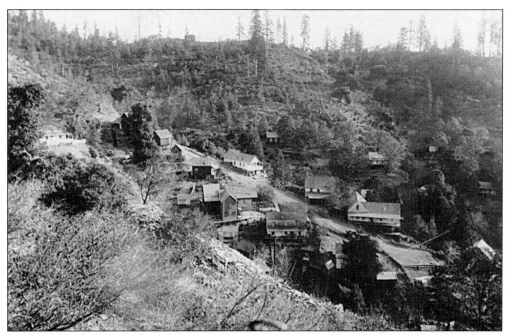

Sunny South, located at the 3,500-foot elevation, was named for its southern exposure. During the winter the camp could have heavy snow for four to five months. But the slope and southern exposure melted the snow more quickly than it had in the earlier camp of Bullion on the northern side of the mountain.

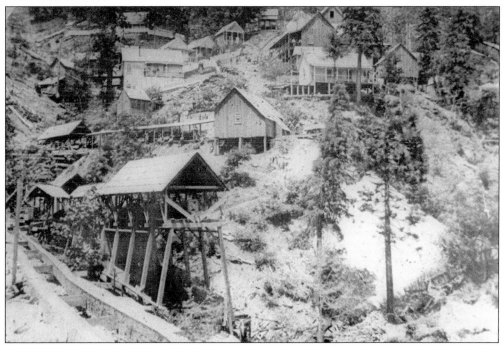

The Hidden Treasure Mine and the mining camp of Sunny South were situated in a steep canyon. The camp consisted of a school, two hotels, two stores, and several houses. The economy of Sunny South depended entirely on the mine.

Augustus "Peg Leg" Miller, who stood six-foot-one, came from Maine to Placer County prior to 1866 and mined in the Deadwood area. His cabin later became the Deadwood School. Because no wagon roads existed to the camp, Deadwood, meaning "a sure thing," was isolated between Michigan Bluff and Last Chance. Supplies and equipment had to be hauled by mule over the precarious Michigan Bluff to Last Chance toll trail through the El Dorado Canyon. The winter of 1860 proved to be difficult in Deadwood because of the depth of the snowfall. Two miners became lost in a snowstorm on Christmas Eve; one was found dead 12 days later and the other was never found. That same evening A.J. Felch and his son Willy were in their cabin preparing to hang stockings for Santa Claus when they heard a crash as an avalanche of snow swept their cabin down the mountain. Felch awoke near the cabin which had been carried down the canyon, but Willy was nowhere to be seen. Thankfully, he was found shortly thereafter, buried but alive and well.

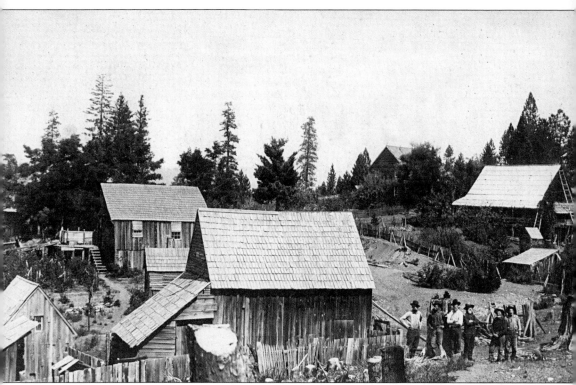

Photographed on August 30, 1885, by D.N. Knowles, Last Chance consisted of about 25 houses on the main street and had 75 inhabitants in 1861. The town also had several saloons, two hotels, a butcher shop, several stores, and two fraternal halls for the Masons, Odd Fellows, and the Sons of Temperance.

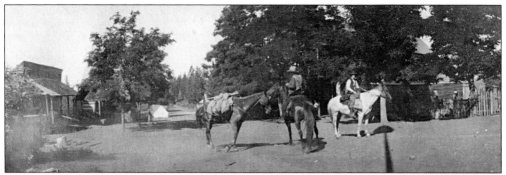

Seen here from left to right are Dave Ray and Mortimer Savage, who came to Last Chance through the Foresthill Divide for supplies and are heading back to work at the Red Star Mine. Gold was discovered at Last Chance in 1850 when one of the miners commented that they were so high up in the mountains that this would be the last chance to find gold. Another miner shot a grouse and when he picked it up the grouse had scratched at the ground when dying and uncovered a rock with gold.

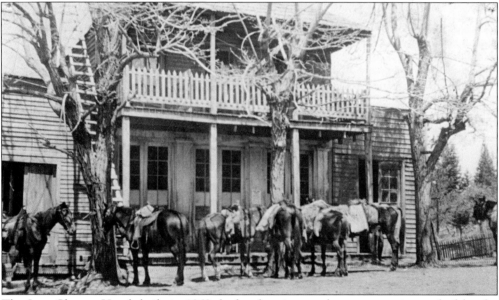

The Last Chance Hotel, built in 1862, had a dormitory-style room upstairs reached by the ladder on the right. The small building to the left was a bakery and candy store. The building to the right served as a washroom and barbershop. Allen and Hosea Grosh joined the rush for gold in 1857 at Gold Canyon, close to present-day Virginia City. Near the head of the canyon they discovered virtually pure silver and are credited with the discovery of the rich Comstock Lode. Hosea died of gangrene from a wound in his foot from a pick in August of that year. Allen and Maurice Bucke left in November on the Placer County Emigrant Road, also known as the Washoe Trail, to take ore samples from their claim to be assayed in California. Slowed by snowstorms in Squaw Valley, they were rescued somewhere near Robinson's Flat and brought to Last Chance. Allen Grosh died there on December 20, 1857, and was buried in the Last Chance Cemetery. His claim papers to their rich silver mine along with the ore samples had been lost in the perilous trek across the mountains. Maurice Burke went to Canada, where he became a doctor.

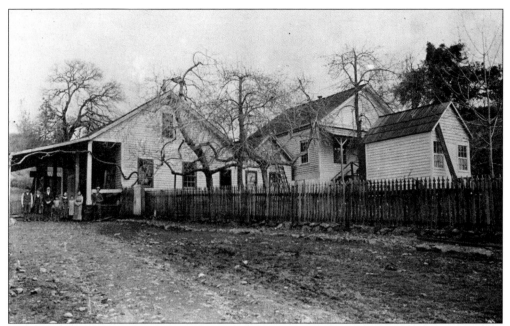

Butcher Ranch was located eight miles from Auburn on the Foresthill Road and at its height had a population of 250 people. The ranch consisted of a post office, drugstore, two hotels, blacksmith shop, carpenter shop, and several houses all on 490 acres. Ed Gilbert discovered gold near Butcher Ranch in 1856. His mine produced more than $80,000 in gold.

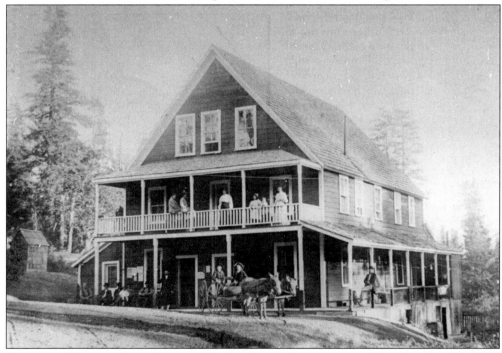

On the road between Forks House and Secret Spring House, George West built the Westville Hotel, along with a large barn, a carriage house, and corrals. The hotel had a three-hole outhouse; two for adults and a smaller one for children.

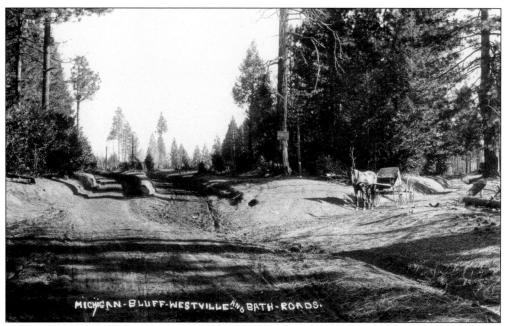

The well-traveled roads to Michigan Bluff, Westville, and Bath pictured here led to settlements along the Foresthill Divide. Beyond Westville was the Forks House, a popular Way Station that became the starting point for the official survey of the Placer County Emigrant Road.

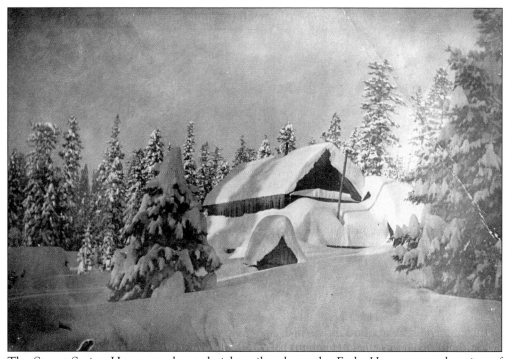

The Secret Spring House was located eight miles above the Forks House at an elevation of 5,486 feet on the Placer County Emigrant Road. In 1852 the road went from Yankee Jim's via Secret Spring House over the Sierra Nevada to the Washoe Valley in Nevada.

Congress appropriated money in 1857 for the construction of two roads from the eastern state boundary to connect with roads coming from the east into California. Counties from Mariposa to Siskiyou held conventions to organize and survey the best route though their county to secure the road contract. The road from Forks House to Secret Spring House, shown here, was already a good wagon road.

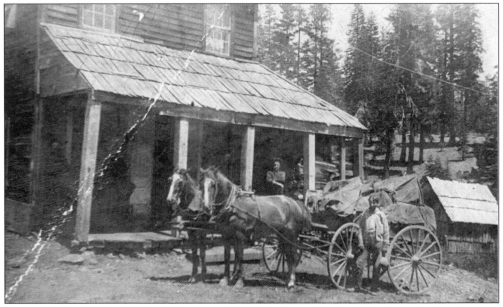

The road from Secret Spring House to Robinson's Flat was approximately 7 miles and continued for 27 miles to Squaw Valley. This road followed some of the same alignment as the current Western States Trail. The Placer County Emigrant Road did not win the state contract and never became a popular route.

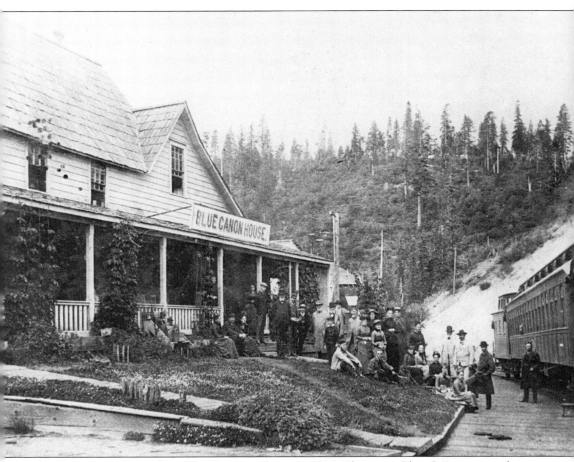

A train stops in front of the Blue Canyon House in 1886. The name Blue Canyon came from miner Jim Blue who had mined the canyon since the early 1850s. The arrival of the Central Pacific in 1866 provided the impetus for a more permanent settlement, with a post office established in 1867, and later, a public school. The population numbered 162 by 1882, and 22 students attended the school.

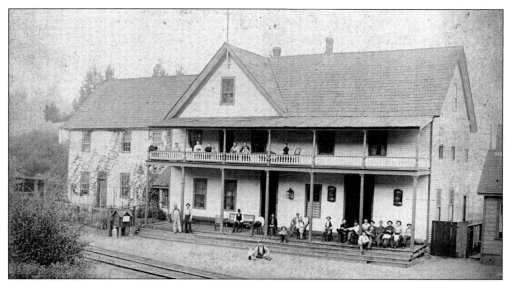

During the 1890s both miners and travelers stayed at the Glendale Hotel, owned by the Charles Peterman family. Mines in this area included the Blue Canyon, the Rawhide, the Redstone, the Golden West, the Azalea quartz mines, and the Lost Camp hydraulic mine. Two stamp mills were still operating in 1902, and one mine was active as late as 1936.

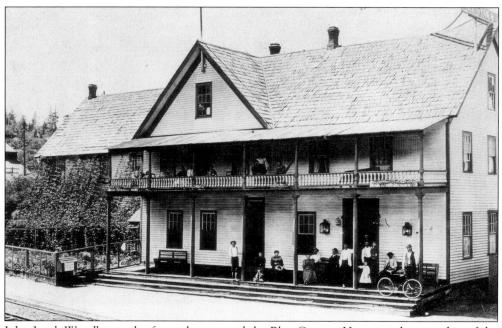

John Jacob Woodbury, who formerly managed the Blue Canyon House, took ownership of the Glendale Hotel in 1898. It was located at the east end of the railroad stop near the entrance of the snow sheds at Blue Canyon, about three miles southwest of Emigrant Gap on what is now Interstate 80.

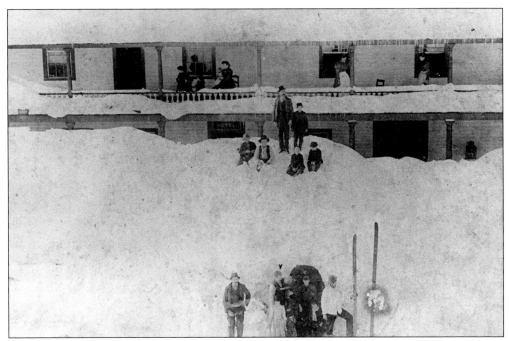

The town of Blue Canyon was situated along the Central Pacific Railroad tracks at an altitude of 4,678 feet. Winters were very harsh with deep snow, as seen in this photo of the Glendale Hotel *c.* 1890. The heavy winter snows caused the school year to begin in early spring as soon as the snow melted enough and run through the summer until heavy snowfall returned.

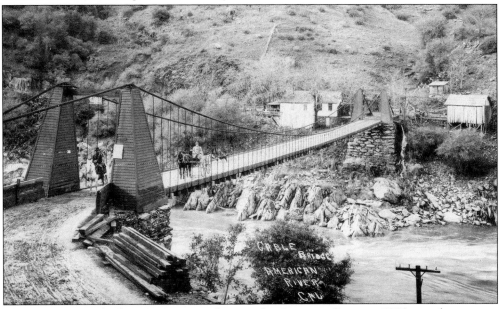

A wire suspension bridge was constructed across the American River in 1865 near the present-day location of the bridge of Highway 49 to El Dorado County, below the junction of the North and Middle Forks of the American River. The bridge was replaced in the 1930s with a larger wire suspension bridge. A new bridge was constructed beside it in 1948, and the wire bridge was demolished.

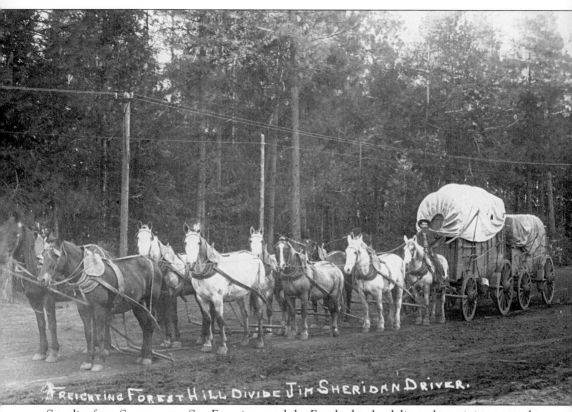

Freighting Forest Hill Divide Jim Sheridan Driver.

Supplies from Sacramento, San Francisco, and the East had to be delivered to mining camps by wagon and in some places pack mules. In Placer County a system of wagon roads developed along the ridges of the mountains and foothills with branches going down the canyons to mining camps along the rivers. Auburn served as a hub for goods going to the mines and camps along the Foresthill Divide and the area between the Bear and North Fork of the American River via Illinoistown (near Colfax). The more remote the mines, the more important receiving news from the rest of the world became to the miners. Jim Sheridan from Butcher Ranch, pictured with his team and wagons, hauled freight daily from Auburn to towns and camps on the Foresthill Divide.

Five

MINING TOWNS

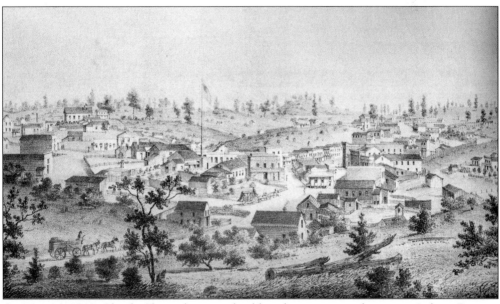

On May 16, 1848, Claude Chana discovered gold in the ravine now known as Auburn Ravine. The mining camp established in the ravine was first known as North Fork Dry Diggings, then Woods Dry Diggings, and later the town of Auburn. The ravine produced a remarkable yield. Samuel Holladay, appointed alcalde (mayor) of Auburn under the Mexican Republic in July 1849, is credited with naming the ravine. William Gwynn, Hudson M. House, and others, proposed various names. Auburn was suggested and Holladay agreed, then Gwynn recited the first line of Goldsmith's poem, "Deserted Village," first published in 1770. The poem begins, "Sweet Auburn! Loveliest Village of the plain." Holladay commented that the red dirt color was in harmony with the name and all agreed. As late as 1864 there was still mining in the town of Auburn. Hanna Lloyd Neal wrote in her description of the town that miners were digging up the streets. "People go picking about with picks and hammers and dig holes anywhere they please. This is prospecting."

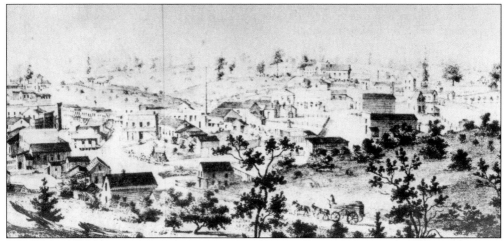

Auburn, pictured here in 1860, grew to a city of over 1,300 residents by the time of the 1850 census and became the county seat for Sutter County in the new state of California in September of that year. The following year the state created Placer County from portions of Sutter and Yuba Counties with Auburn as its county seat.

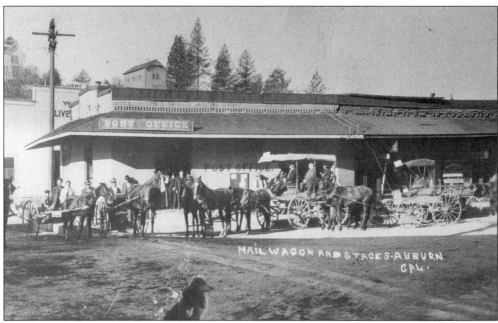

Mail wagons line up in front of the Auburn Post Office, built after the fire of 1855. Auburn was the only postal station for Placer County in 1851. Once a month, the *Placer Herald* newspaper listed letters waiting for pickup at the post office. The first list on October 23, 1852, filled two columns. Although other towns in Placer County had post offices, by 1855 the list of letters waiting at the Auburn post office had doubled. In the wagon from left to right are Kinley Biggs of Wolf Route; a local carrier from Trail; a local paper carrier; and Harry Branch, mail carrier (Auburn, Foresthill Stage, and rural delivery). Mr. and Mrs. Arthur S. Fleming stand at the door of post office in 1909.

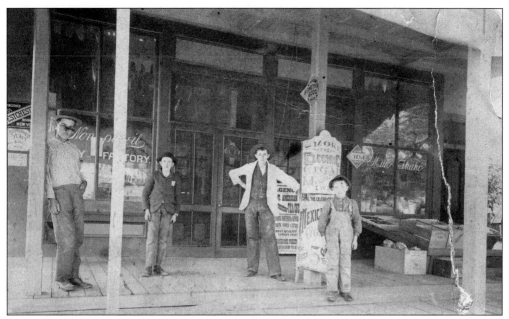

Located at the intersection of early wagon roads and trails to mines running north, south, and east, Auburn became an important trade and transportation center. Pictured here are four youths posing in front of Walter W. Lyman's General Merchandise Store in Auburn.

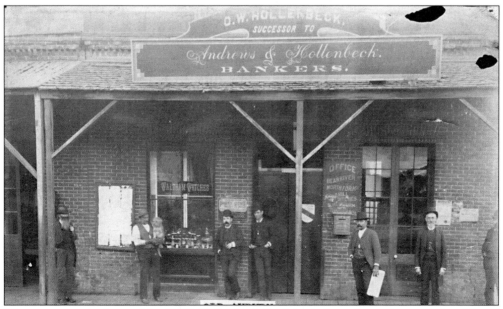

Men are posing in front of the O.W. Hollenbeck Bank in Auburn, located next to the old post office and across from the fire station in Old Town. This business was the successor of the Andrews and Hollenbeck Bankers' office. The building also housed Waltham Watch Shop and the office of S. Washburn, superintendent of the Bear River, North Fork, and Gold Hill Ditches. These buildings were known as the Plaza or Center Block.

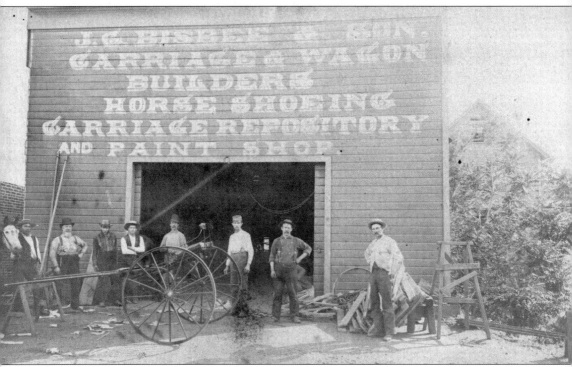

The shop of J.G. Bisbee and Son, carriages and wagon builders, horse shoeing, carriage repository, and paint shop were all located in Auburn on Washington Street near the current Claude Chana statue. John and Mary Bisbee left Kansas for the California gold fields, via New York, the day after their wedding in November 1858. They crossed the Isthmus of Panama and arrived in Iowa Hill in January 1859, where John was a blacksmith. Widowed with six children in 1877, John remarried but divorced after four years because he felt his new wife did not treat him or his children with respect. In 1880 he was elected county treasurer, requiring his family move to Auburn. He also held the offices of coroner and public administrator. After retiring from public life, John went back into the blacksmithing and carriage-making business. Although his building burned twice, with the usual pioneer spirit, he rebuilt each time. He was awarded the building contract for manufacturing the ironwork needed for the woman's cell at the Court House and was later made manager of the Pioneer Fruit Company in Auburn.

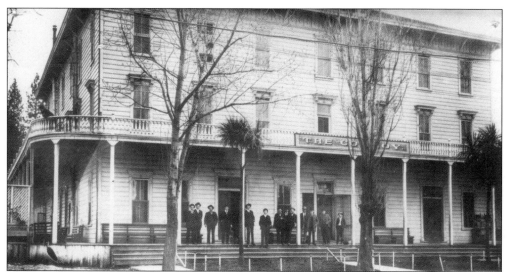

The Conroy Hotel, located on Lincoln Way, is currently the Auburn Promenade (formerly the Auburn Hotel). It was constructed in 1880 by Sam Putnam and known as the Putnam House; it burned and was rebuilt in 1883. John W. Thompson purchased it for $10,000, and in June of 1883 it was sold at auction for $8,500 to J.M. Lowell, F.D. Adams, and A.J. Drynan of Dutch Flat. In 1899, Sheriff William Conroy bought the hotel and ran it for nearly 10 years.

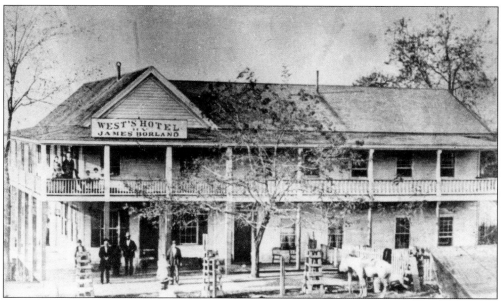

West's Hotel in Auburn, across Lincoln Way from the depot (now the chamber of commerce office), was constructed in 1866, burned in 1868, and rebuilt in 1869. James Borland bought it and made additions. W.A. Freeman purchased the building in 1882 when it became known as the Freeman Hotel. It featured an outdoor dance floor on springs. In 1890, every room in the hotel was electrified. The hotel was torn down in the 1970s to make room for a grocery store chain and business complex.

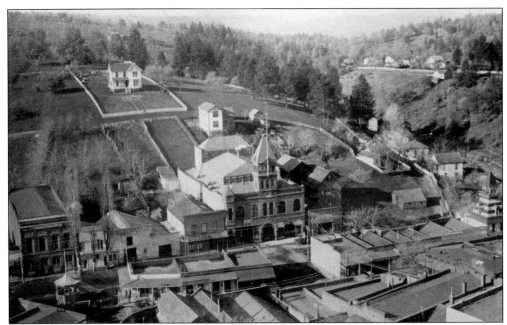

Pictured here is the view of Old Town Auburn from the courthouse c. 1898. The center building is the city hall, which burned in 1905. The firehouse is at the far right (now moved to across the street from the city hall location). The building at the far left was the American Hotel, now the Shanghai Restaurant and Bar. The Snowden House, encircled by a white fence, sits on the hill.

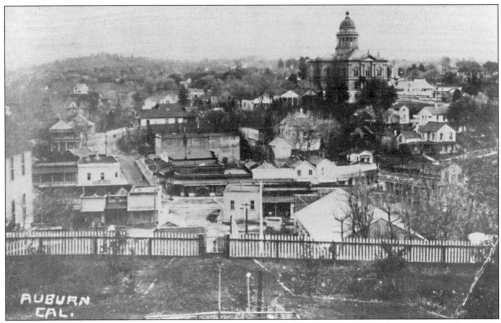

This view is from the Snowden House toward the courthouse. The street on the left side of the picture is Commercial Street. Directly above the gate in the foreground is what is now Marybelles restaurant on the corner of Commercial Street and Lincoln Way. The American Hotel (now the Shanghai Bar) can be seen through the bushes on the far right of the picture.

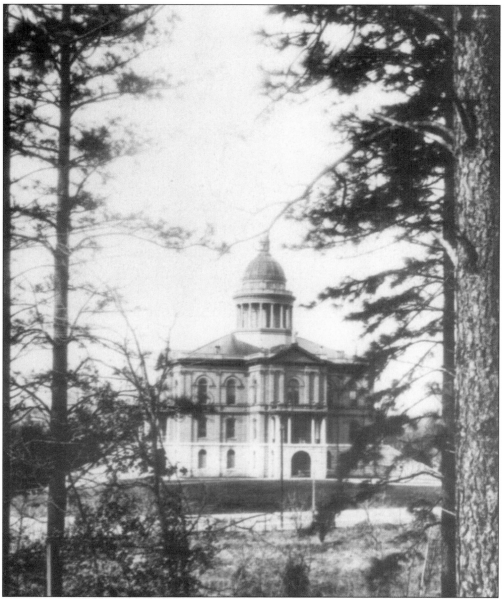

This was Auburn's third courthouse, completed in 1898. The first was a log structure located approximately between Interstate 80 and Maple Street. A new wooden courthouse was completed in 1853 at the same location as the current courthouse.

This lithograph of Foresthill was drawn in 1857. James Fannon, M. Fannon, and R.S. Johnson established a trading post called the Forest House on the divide between the Middle Fork of the American River and Shirttail Canyon in 1850. The Forest House was on the road to Bird's Valley, Humbug Bar, Horseshoe Bar, Stoney Bar, and the mines further up the divide. Although there was no mining in the near vicinity of the house at the time, the trading post became so popular that a hotel was added.

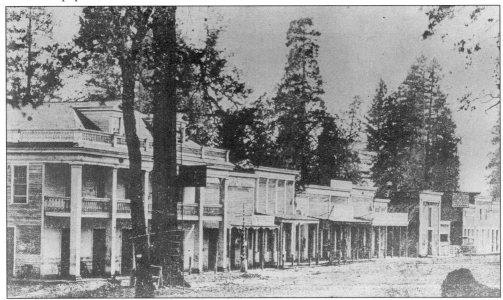

The double-wide main street of Foresthill was lined with hotels and stores. The Forest House, pictured on the left, is actually the second Forest House; next to it is the barber shop, the Alta Express Office, and Levin and Better's Store. Foresthill had a newspaper in 1859 that described the town: "blocks of fire proof stores, hotels, elegant saloons, banks and express offices, and pleasant flower-adorned residences."

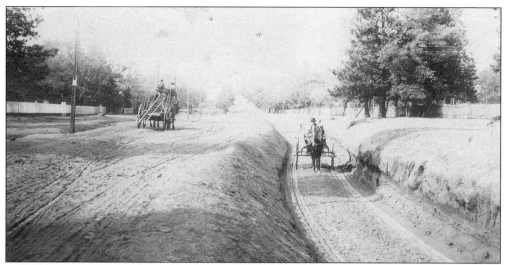

W.T. Henson and Brown & Company constructed the Middle Fork House a short distance up the road from the Forest House in 1851. In the winter of 1852–1853, gold was discovered in a landslide in Jenny Lind Canyon. Miners staked claims throughout the area including the Deidesheimer, Rough and Ready, Independent, Northwood and Fast, Gore, Alabama, Dardanelles, Eagle, Garden, and India Rubber. The town that would supply these mines became known as Foresthill. Here the two-lane, extra-wide main street of town clearly showed the preferred lane.

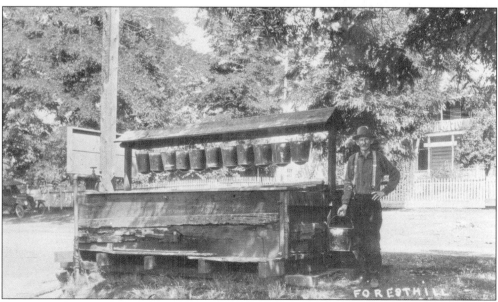

Fire was a threat to all mining towns and Foresthill was no exception. In September 1873, nearly half the town burned, then again on Christmas of 1886, and again in 1918. In the middle of Main Street, several water bucket stations were set up to quickly extinguish fires. A few of the water bucket stations remain today.

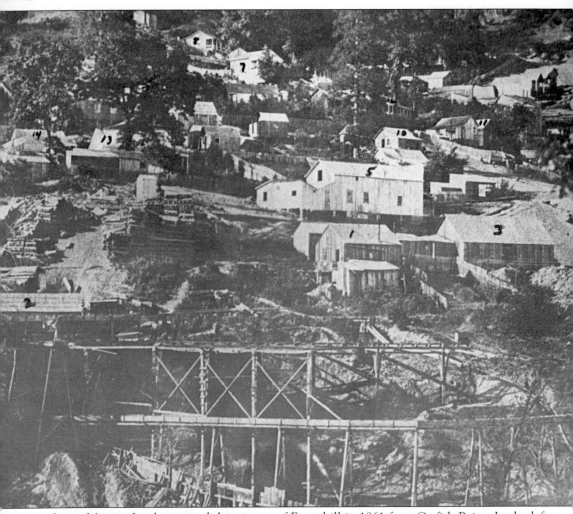

James Monroe Jacobs snapped this picture of Foresthill in 1861 from Catfish Point. In the left foreground above the flume of the Dardanelle ditch is the Jersey Mine. Above and to the left are the John Rains house, the John Gehrman house, and the Jenny Lind Mine. At the far left are the George Washington Reamer house (owner and superintendent of Jersey Mine), the Thompson-Schmegler house, and the Henry Maye house. At center right, the large white building is a miners boarding house. Above the boarding house is the John Brown house. At the far right, top, is a dance hall, and the second from the top left is the A. Huntley house. At the top is the Glover house. John H. Gehrman identified the buildings in the 1930s, and Jane Howell Watters, who grew up in the house next to the Maye House, confirmed some of the identifications and questioned others in the 1960s. James Monroe Jacobs ran away from home, crossed the plains in the 1850s, and became a miner and photographer in Placer County. He is thought to be the first permanent photographer in the gold country. His main studio was located in Auburn, but he traveled the mining camps of Colfax, Bath, Michigan Bluff, Yankee Jim's, and Foresthill annually.

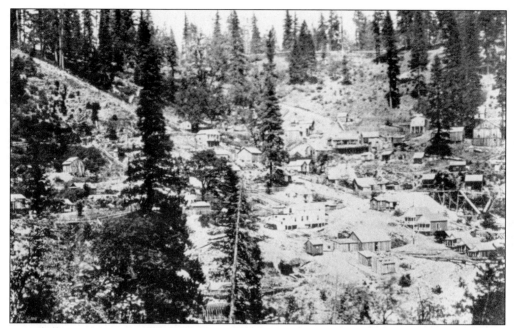

Foresthill grew from a small trading post established in the fall of 1850. At that time the mining town was down slope from the current town site. In the wake of a fierce winter storm that struck late in 1852, a slide at the head of Jenny Lind Canyon exposed a rich area of gold. When miners arrived to assess the damage they discovered gold in the slide that yielded from $2,000 to $2,500 a day, resulting in a major mining boom.

In 1854, the trail from Illinoistown (near Colfax) to Iowa Hill was made into a wagon road at a cost of $35,000. The wagon road twisted and turned down the steep, rugged canyon, crossed the American River, and snaked up the other side of the canyon to the mining town of Iowa Hill. Charles Rice was toll collector and superintendent of the road.

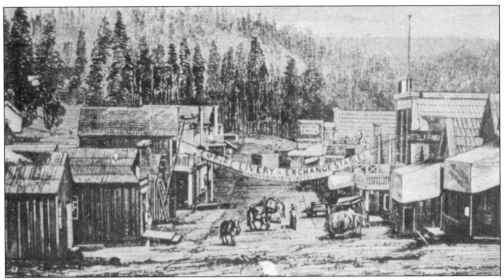

In 1852, rich diggings were discovered at Iowa Hill. In 1853, the town of Iowa City (later Iowa Hill) sprang up from one tent store and three log cabins. The town, illustrated above in 1959, with the usual array of saloon/gambling houses, hotels, butcher shops, provision stores, dry goods, and clothing stores, also had a bowling alley, theater, and ice cream parlor. There were two churches, a Masonic Hall, and an I.O.O.F. Hall.

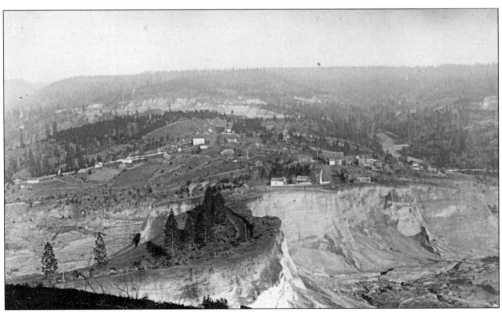

The road to Iowa Hill is visible on the "isthmus" between hydraulic mines with the town in the background. Charles Rice sued the Orion Mining Company and prevented hydraulic mining within 100 feet of the road. It is probable the road may have been washed away without the court order. This photo was taken c. 1880.

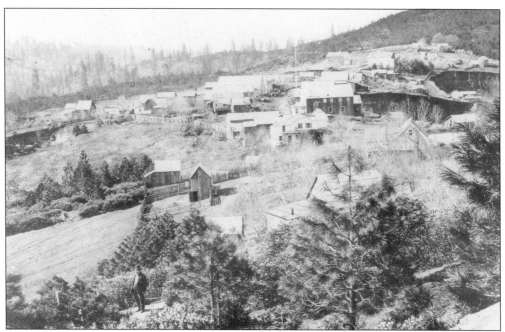

Iowa Hill was called "Magic Town" due to its rapid growth: the population totaled between 1,400 and 1,600 people in 1854. It was a roaring, raucous mining camp with bull and bear fights held at the top of Sugarloaf (a mountain overlooking Iowa City), gambling, and, unfortunately, one lynching. In an effort to bring stability, the Mountain Blues, one of the first state-regulated militia in Placer County, was formed there in July 1855.

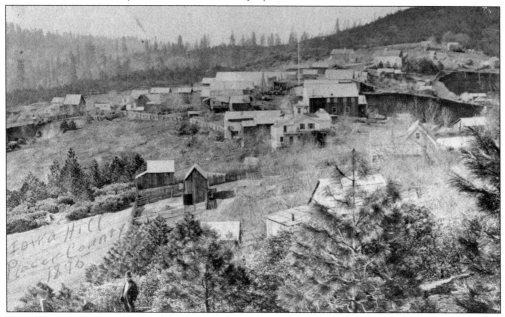

As surface gold was depleted in 1875, the miners of Iowa Hill dug into the ancient river channels that meandered through the Iowa Hill Divide. The divide was so honeycombed with approximately 600 tunnels that the town itself was in danger of sinking away. Many of the hills were washed away entirely during 30 years of hydraulic mining. This photo was taken c. 1890.

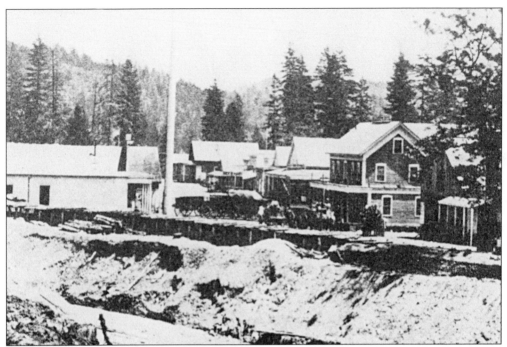

The town of Gold Run was named for the Gold Run Ravine, a tributary of Canyon Creek, with its headwaters at the town site. By the 1870s, the town was described as having 11 saloons, four stores, a barbershop, three blacksmith shops, three hotels, a bakery, a tin shop, two shoemakers, two butcher shops, two halls, a post office, church, school, and stable.

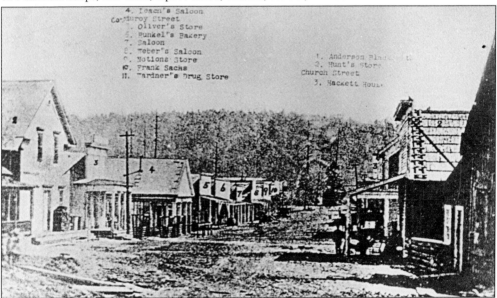

A number of businesses are shown here on Main Street of Gold Run in 1870. Buildings on the left side of Main Street are, from front to back, a residence, Odd Fellow's Hall, Brown's Bank, Leach's saloon, Oliver's store, Runckel's bakery, a saloon, Weber's saloon, notions store, Frank Sachs, and Wardner's drug store. On the right side, from back to front, are Anderson's blacksmithing, Hunt's store, and the Hackett House Hotel.

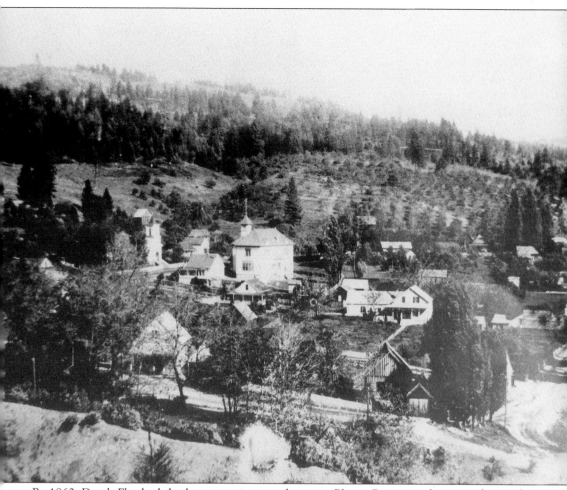

By 1860, Dutch Flat had the largest voting population in Placer County and remained one of the largest cities in the county for the next decade with numerous German and Prussian immigrants. They originally came to mine but quickly became merchants and dominated the trade. The Dutch Flat School, which started in 1856 and closed in 1962, is seen in the center of the photograph. The school building pictured was constructed in 1898. The Methodist church across the street was built between 1859 and 1861. The Dornbach brothers settled in the flat near the school. At the upper right is the old Runckel family orchard that dates from the turn of the century. This photo was taken c. 1910.

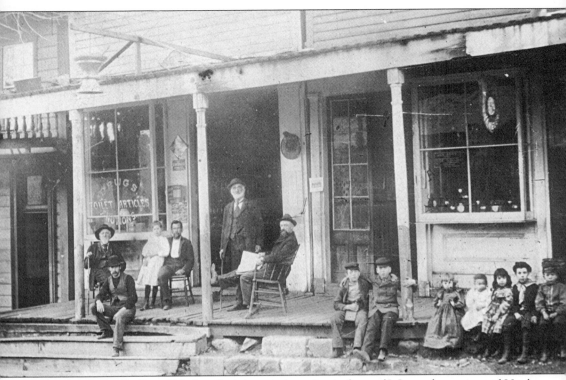

Sophie Cadwaller Runckel identified the people posing in front of J. Jones drug store and Uncle Sam's saloon. From left to right are Jim Broiles, Elias French, Annie Jones, Johnny Jones, Dr. Martin, A.E. Perry, Walter Perry, Mallows Trousdale, Sibyl Rule, Hadyn Rule, Inez Rule, Willie Mendy, and Willie Bellows. The drug store, formerly Strong's store, is the location where the original articles of incorporation for the company that would become the Central Pacific Railroad were drawn up by Dr. D.W. Strong and engineer Theodore Judah. Dr. Strong paid for the survey and went with Judah over the Sierra Nevada to the Truckee River. Judah, determined to build a railroad over that route, sought investors, and the Central Pacific Railroad was formed with the following directors: Leland Stanford, Charles Crocker, James Bailey, Theodore Judah, L.A. Booth, C.P. Huntington, and Mark Hopkins, all of Sacramento, D.W. Strong of Dutch Flat, and C.P. Marsh of Nevada City.

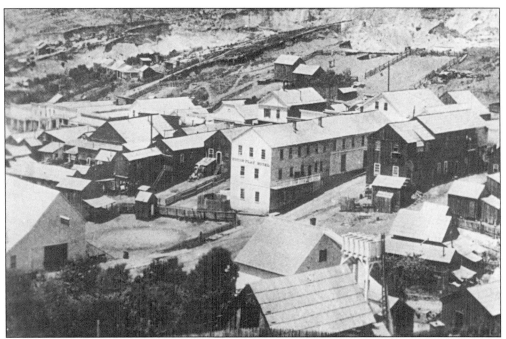

Carl and Joseph Dornbach founded Dutch Flat in the spring of 1851. They came with their wives by wagon from Belleville, Illinois, and were the first families to settle on the small grassy flat. The town grew rapidly between 1858 and 1861 as other miners and their families settled there. Several nearby hydraulic mines supported the new town. This view was taken in 1866.

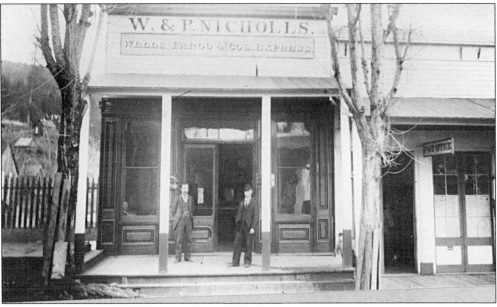

John Nicholls and William Nicholls Jr. stand in front of the W. & P. Nicholls Wells Fargo & Company Express building in Dutch Flat with the post office to the right, c. 1900. By 1860, Dutch Flat reported one-tenth of the entire population of Placer County. Hydraulic mines in the area were producing great quantities of gold, and the town prospered. In the 1860 elections, 501 white men voted—more than any other town in Placer County.

William Sharon owned the Placer Hotel in Dutch Flat. At one time there was a Christian Science reading room in the hotel. The hotel was sold in 1921 to a J.C. Latham from Kansas who dismantled it and took the wood to Atsacadero to build a private residence.

Pictured here is the Dutch Flat Hotel, the bridge to the annex of the hotel, and the town pump, seen in the foreground to the left. Many buildings remain from the 1850s to the 1860s as Dutch Flat did not have the large fires that destroyed buildings in most early mining towns. The original part of the Dutch Flat Hotel, constructed in 1854, still stands. Other early buildings include the Dutch Flat Trading Post, Odd Fellows Hall, and Masonic Hall.

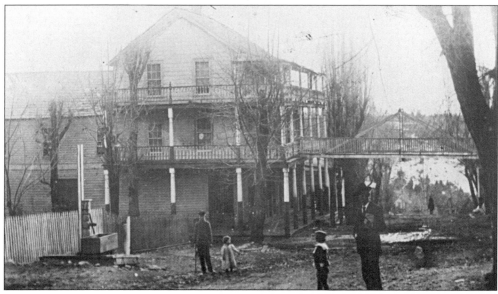

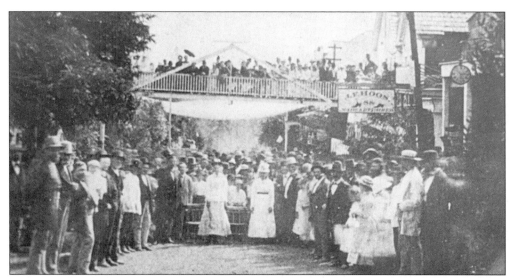

A large crowd gathers on the main street of Dutch Flat and on the bridge to the hotel annex on the right. As mining declined in the area, logging and fruit-growing (apples and pears) bolstered the economy of the town. Logging remained a strong industry through the 1900s. Dutch Flat became a popular summer resort and summer home area during the 1900s, especially for people in the San Francisco Bay area.

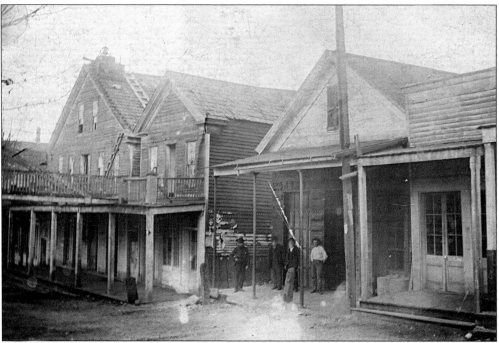

Pictured here are four gentlemen standing on the board sidewalk in front of the National Hotel. Partially visible is the bridge crossing Main Street to the Dutch Flat Hotel (not shown) and the Dutch Flat store. In 1860, Dutch Flat consisted of 7 grocery stores, 17 saloons, 8 clothing and dry goods stores, 2 breweries, 3 blacksmith shops, 2 hardware stores, 2 tin shops, 2 hotels, a drug store, a carpenter's shop, a cabinet shop, a restaurant, 2 butcher shops, a bakery, 3 schools, and a church.

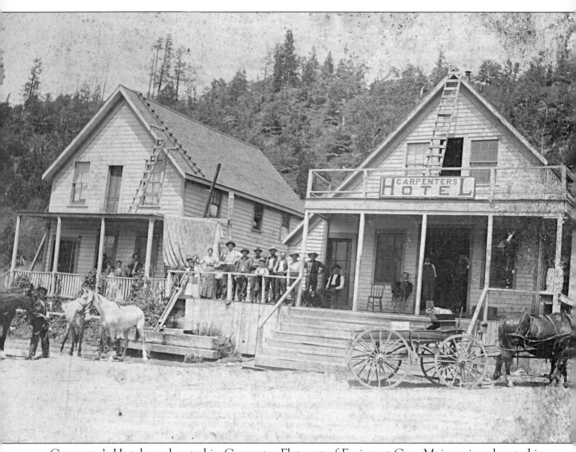

Carpenter's Hotel was located in Carpenter Flat east of Emigrant Gap. Major mines located in the area included the Red Rock, Texas, Van Avery, Zeibright, the Golden Channel, Golden Nugget, Lost Camp, Shell, and Wild Yankee. A group of people pose on the porch and in front of the hotel in 1880. Note the water pump to the left of the woman. A wooden chute runs down to the horse trough in front of the porch. The ladders are placed for snow removal. The ladder on the roof serves as a snow break for the stove pipe attached to the side of the building.

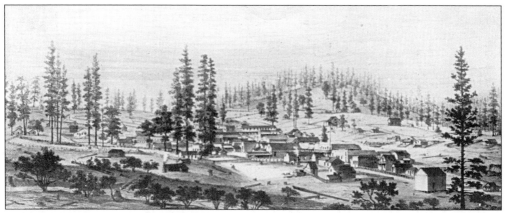

Yankee Jim's was named for Jim Robinson, a horse thief who in 1849 hid stolen horses in a corral located on the site that would become a mining camp. In the fall of 1850, four miners from Missouri drove the first wagonload of supplies to the site. Col. William McClure began one of the earliest orchards in Placer County in 1853 with seedlings he shipped around Cape Horn from Philadelphia. This lithograph was drawn by Kuchel and Dresel in 1857.

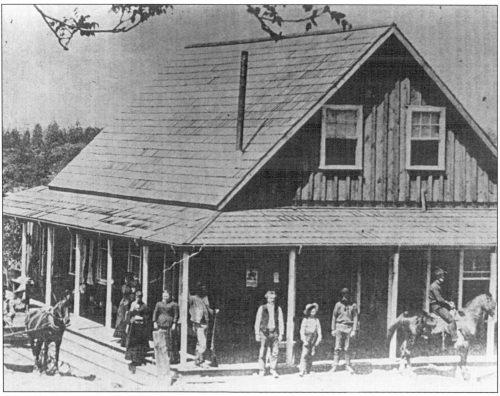

The Glenbrook Hotel in Yankee Jim's was constructed in 1884 and burned in 1929. William Banbrock, a professional photographer in both Foresthill and Auburn, took this photograph in 1887. Pictured from left to right are Mrs. Gines (in buggy), Etta Duncan, Belle Joninon, Lizzie Duncan, Mrs. Duncan, Bob Smith, Adam Duncan, Charlie Burke, Jim Colwell, and Dougal Duncan.

The old Norton house in Yankee Jim's was built in the 1850s. Mr. Norton operated a mule train through Devil's Canyon between Auburn and Yankee Jim's. Mrs. Norton is said to have run a boarding house; however, some said it was a "honky tonk house."

The old Norton house dining room is shown here as it looked when Mrs. Edna Eddy purchased it in 1933. She discovered a secret drawer in the bottom step of the stairway leading to the second floor. The drawer contained $100 in gold pieces in denominations of 5, 10, and 20; a few gold nuggets; gold cuff links; a black beaded chain; a telegraph dated 1869 to Mrs. E.M. Norton stating that her "mother no better, failing fast;" and Mrs. Norton's will, dated July 22, 1880.

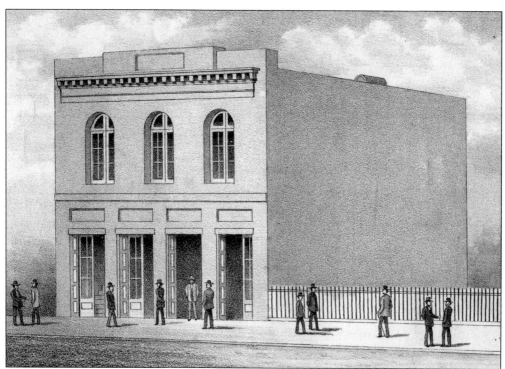

Nicholas Quirolo, a native of Italy, settled in Todd's Valley in 1861 and opened his store, pictured above. He came from Genoa, Italy, to New York in 1854 and was a sailor for two years before arriving in San Francisco in 1856. He worked the mines of Calaveras County, was a clerk at Campo Seco, and had a store in Jenny Lind for a year and a half before settling in Todd's Valley. (From *History of Placer County* by Myron Angel, 1882.)

Quirolo's store was one of last remnants of the once thriving town of Todd's Valley. The town was founded to draw trade from the miners of Stony Bar, Horseshoe Bar, and Resters Bar on the American River as they came up the divide. In 1859, a fire consumed the town with the exception of two brick buildings. The town was quickly rebuilt. Masonic and Odd Fellows lodges and two temperance orders were established at Todd's Valley.

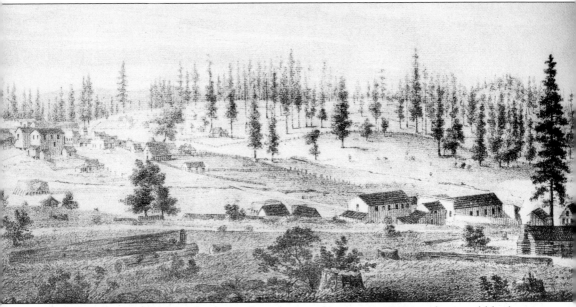

Dr. F. Walton Todd built a log house for a store and tavern in 1849 in what would be known as Todd's Valley. By 1856, the town consisted of three stores, two hotels, two restaurants, three blacksmith shops, two bowling saloons, and numerous saloons. This lithograph was drawn by Kuchel and Dresel in 1857.

Six
SETTLING DOWN

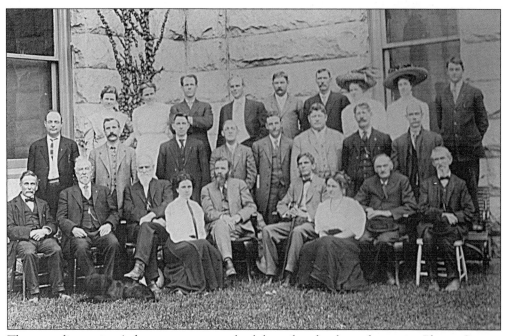

The courthouse in Auburn serves as a backdrop for the key players in Placer County government at the turn of the century. Pictured from left to right are (front row) O.F. Seavey, board of education president; John G. Bisbee, coroner; unidentified, possibly George Bisbee, county supervisor; Marguerite Seavey; James Prewett, judge; A.B. Reading, court clerk; Patricia Johnson, county clerk; R.G. Evenden, county surveyor; and James Breslin, probation officer; (middle row) Elmer Gum, sheriff; George McAulay, sheriff; Sam Wood, sheriff; unidentified; Charles A. Geisendorfer, county supervisor; James J. Brennan, county supervisor; Moses J. Predom, county supervisor; and J.W. McFadden, county supervisor; (back row, standing on bench) Lulu Waldo, deputy superintendent of schools; Annette E. Shane, superintendent of schools; Marshall Z. Lowell, county clerk; Ivan H. Parker, county recorder; (standing on ground) Frank "Big Dip" Dependener; Jonathan Fulton, jailer; Georgia Lardner, assessor and tax collector; Mildred Steven, assessor and tax collector; and Charles A. Tuttle, district attorney.

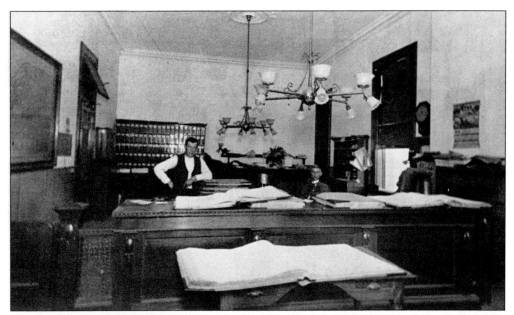

Two gentlemen sit in the Placer County assessor's office in 1899, which was located on the second floor of the Auburn courthouse. Alfred Lewis was elected Placer County's first assessor in 1851. As an assessor, Lewis and his successors were responsible for setting values on properties, carrying out tax regulations, creating and maintaining maps of assessed property, as well as processing recorded documents and ownership changes.

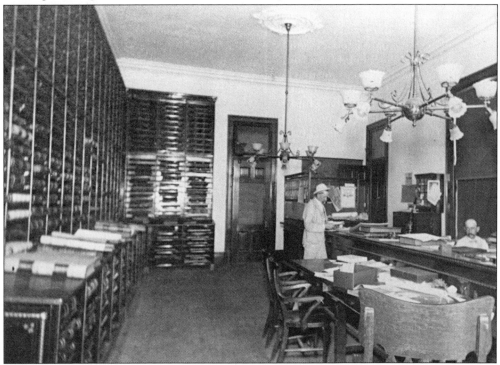

Seated behind the counter in his office at the Auburn courthouse, Charles Bilkey, Placer County recorder in 1899, maintained official documents.

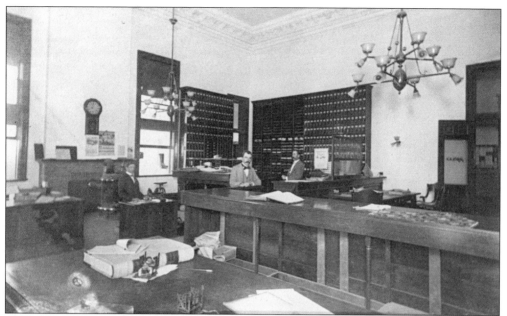

Three gentlemen work in the county clerk's office, located on the third floor of the Auburn courthouse in 1899. The first elected county clerk was James T. Stewart; however, the results were contested. Ballot boxes were placed along well-traveled roads and were attached to trees for the voters' convenience. Some precincts with no more than a few dozen citizens reported several hundred votes for their favorite candidate. Stewart solved this problem by appointing Hiram R. Hawkins, the man who contested the results, as his deputy.

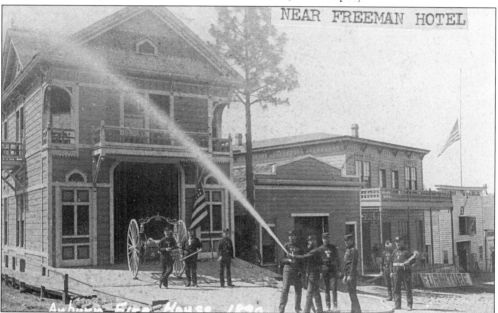

Firefighters in the uptown station in Auburn needed (and got) plenty of practice putting out fires. In 1855, 80 buildings were ruined in an hour and twenty minutes; in 1859, 58 buildings were destroyed; in 1864, 35 buildings were leveled, in 1870, upper Auburn was devastated by a fire; and a major fire caused $60,000 in damages in 1897.

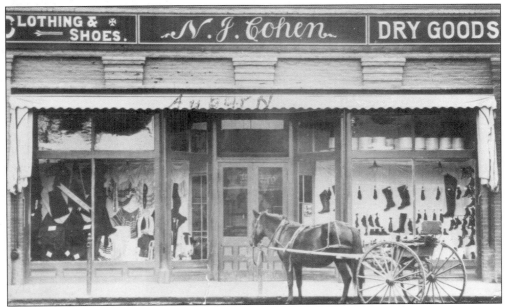

N.J. Cohen's dry goods store windows display women's and men's clothing, footwear, and hatboxes. William Gwynn and H.M. House established the first general store in Auburn in 1849. As Auburn developed from a raucous mining town to a transportation hub and agricultural community, stores like N.J. Cohen dry goods were able to provide them with more luxury items.

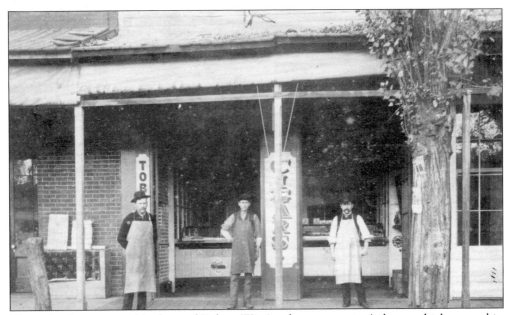

Three shopkeepers stand in front of Robert Wise's tobacco store in Auburn, which opened in 1892. Robert Wise emigrated from Prussia and arrived in New York in 1873. He traveled through Virginia and San Francisco before arriving in Auburn. On a good day, his workers were able to roll 1,000 cigars. Overall he sold about a quarter of a million cigars.

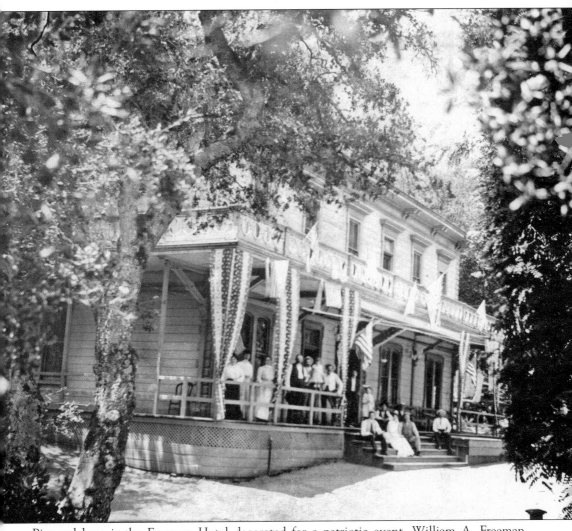

Pictured here is the Freeman Hotel decorated for a patriotic event. William A. Freeman, originally from Indiana, supposedly pulled $25,000 worth of gold from the earth in Forest Hill and was able to purchase a shabby hotel from James Borland in 1882. Under the proprietorship of Freeman, the hotel became known as "your home away from home." At the turn of the century, the Walsh family took over ownership, and modern amenities, such as phones, were added. It was a very popular hotel, most likely because of its location next to the railroad station. Many early celebrities and prominent people were said to have visited the Freeman in their travels.

Two gentlemen stand at the altar of Auburn's Methodist church at the turn of the century. Dr. John Riggs Crandall originally arrived in 1850 or 1851 to help dig a canal to bring water to the North Fork Diggings. In 1852 or 1853, Harriet, his wife, traveled by way of the Isthmus of Panama to join her husband. Harriet, along with Mrs. E.T. Loving and Ms. Bell Love, helped raise the funds—principally from gambling houses—to build the Methodist church in 1858, after the fire of 1855 burned the previous church.

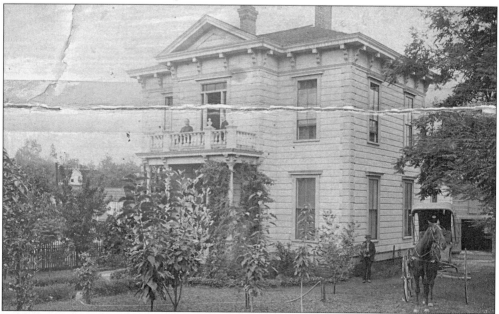

Two men stand on the balcony of the St. Theresa's Parish Home around the turn of the century. Bishop Alemany, archbishop of San Francisco, dedicated the church in 1859. During the 1870s, Father Kelly would travel by train from Sacramento to Folsom for an early mass every third Sunday of the month. For the afternoon mass, Father Kelly traveled by buggy to St. Theresa's parish in Auburn.

Pictured here is an unidentified ranch located in Auburn. As mining switched from locally owned small operations to corporate ventures run by out-of-town investors, many miners turned to ranching. Placer County's new "gold" was agriculture.

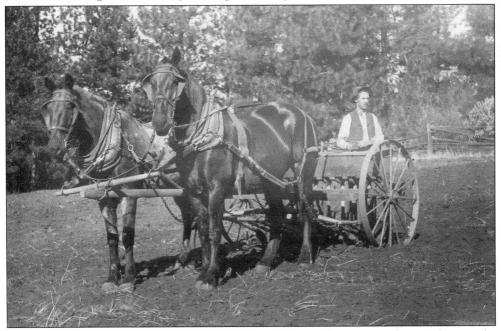

Henry Benfelt is seen here plowing his fields. The miles of ditches once used to supply water for hydraulic mining and drift mines now served the farmers and ranchers of Placer County.

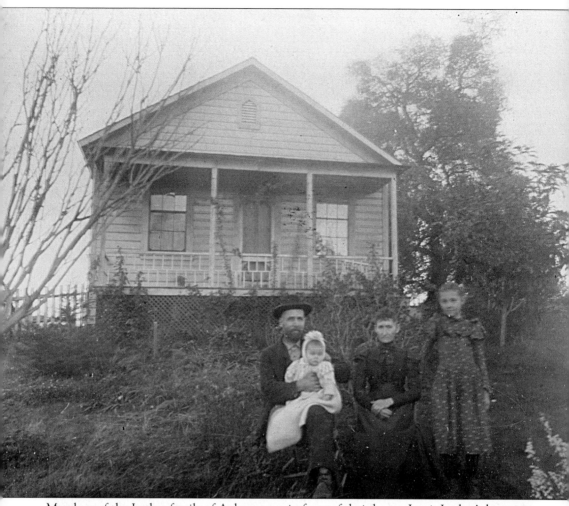

Members of the Luther family of Auburn pose in front of their home. Lewis Luther's home was in rural Auburn on the corner of Luther Road, his namesake, and Interstate 80. Lewis Luther settled in Auburn in the late 1880s, but he owned a letter from a Daniel Luther who wrote about the hardships of living in Auburn in the 1850s. In a letter written in May, addressed to his "Dear Sis," Annie Collins, Luther wrote

I suppose you would like to hear the news of California. We live here like hogs. More than anything else we eat pork and flour and pilot bread mostly. We have enough work when we are mind to. The rainy season is over, I suppose now. We have suffered everything since last fall that human flesh can endure, I can tell you. I wish that you could speak to William and David. Tell them from a cousin's heart not to think of coming here to suffer the pangs and sickness of this country. It is as hot here in the middle of the day as at home in July and at night cold enough for two coats.

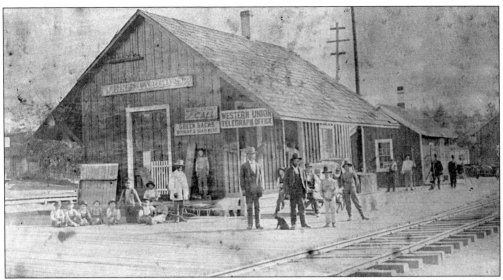

Many towns, like Colfax, sprang up with the construction of the railroad. The town of Colfax was named after Schuyler Colfax, the speaker of the U.S. House of Representatives in the 1860s and Grant's vice president in 1868. While on a trip in 1865 to tour the Central Pacific lines with Leland Stanford and Charles Crocker, soon-to-be Vice President Colfax was well received in Dutch Flat, Donner Lake, Marysville, and other foothill towns.

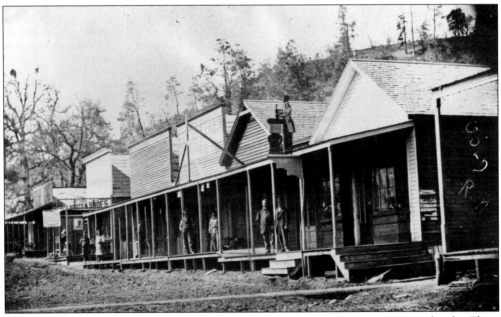

Shopkeepers stand outside their stores in Gold Run around 1860. A reporter for the *Placer County Republican* recalled "when hooped skirts were all the rage, and every dry goods store had them suspended from the wooden awning that reached from the building to the outer edge of the sidewalk in front of each store, as a luring sign to the women. If you saw a woman in the distance coming towards you, her figure resembled the Liberty Bell with a sawed piece of timber six-by-six two feet long with a squash stuck on the top for a head."

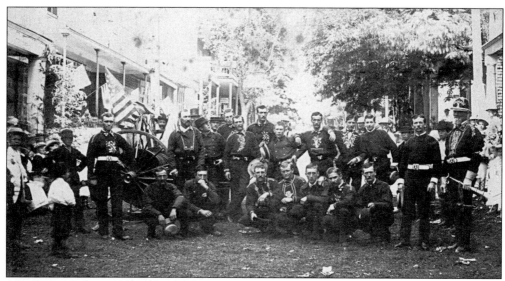

The dapper volunteer firefighters of Dutch Flat celebrate Fourth of July. Dutch Flat was well known for its Fourth of July parades.

Through the subscriptions from the people of Dutch Flat, the Odd Fellows, the Redmen, the Masons, and the Reliance Hose Company, the Dutch Flat hearse was purchased to serve the people of the town. The hearse ran from 1875 to 1941.

A man receives a shoeshine outside the baths at Forest Hill around the turn of the century. Logging became big business in Forest Hill after the mining prospects dwindled.

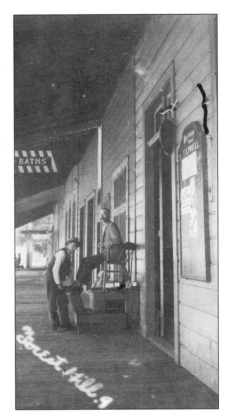

The Forest House provided a room and a warm meal to the weary traveler. R. Burry was the proprietor when this picture was snapped around the turn of the century. This building, the second Forest House, burned down in December of 1918.

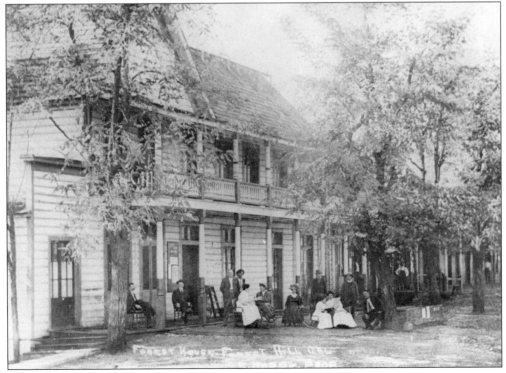

R.N. Scott constructed this building, known as Fraternal Hall. Robert Jones, of Jones and Barry real estate, added four feet to the second floor to make the building larger. The citizens of Newcastle used the building for community events. Newcastle was originally at the center of the Secret Diggings Mining Camp. This picture was snapped c. 1892.

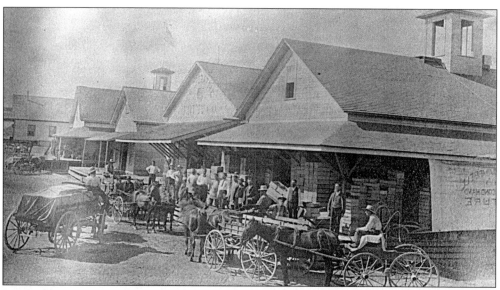

Pictured here c. 1900 are several of the seven fruit-shipping houses in Newcastle. During 1898, Newcastle shipped one-fourth of California's deciduous fruit. By the 1900 fruit season, Newcastle shipped 1,054 cars carrying 27,404,000 pounds of fruit.

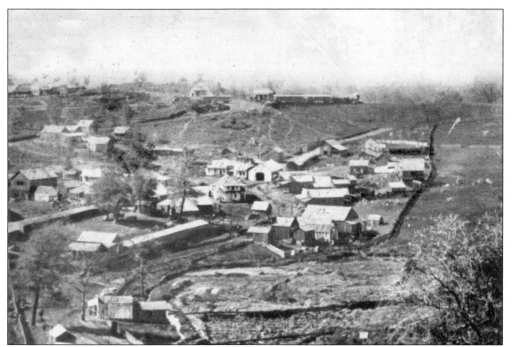

Most of the gold and the gold miners vanished from Newcastle by 1859. Some miners who did remain in Newcastle fell back on their former profession—ranching. Fruit trees seemed to prosper on the fertile land, and Newcastle's fruit era began.

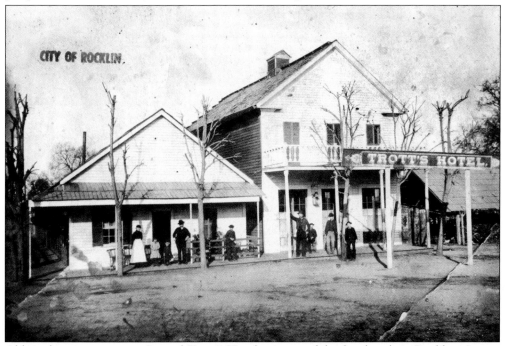

Able to house many men, Samuel Trott's Hotel was one of the first hotels in Rocklin. At one point, Rocklin had only one church and nine saloons. Of course, as the people of Rocklin settled down and built more churches, the number of saloons decreased.

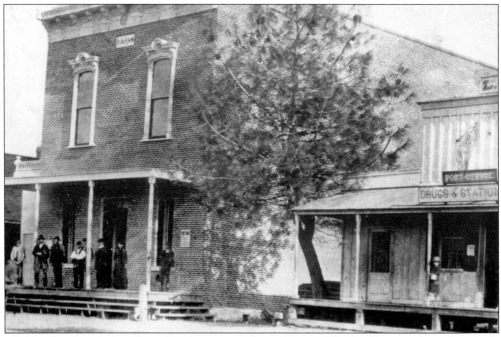

Rocklin developed after the railroads came to Placer County. The building on the right is L.G. Smith's drug and stationary store, and the building on the left, built in the early 1870s, served as the Free Masons Granite Lodge #222. This picture was taken *c.* 1882.

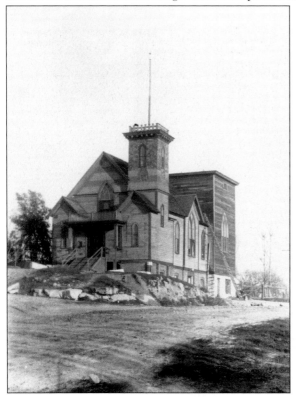

Originally built in 1905 as the Methodist church, this building eventually became the Rocklin labor Temple. It sat at the corner of San Francisco Street and Rocklin Road in Rocklin. The beautiful building was torn down in 1930.

Seven

ENTERTAINMENT

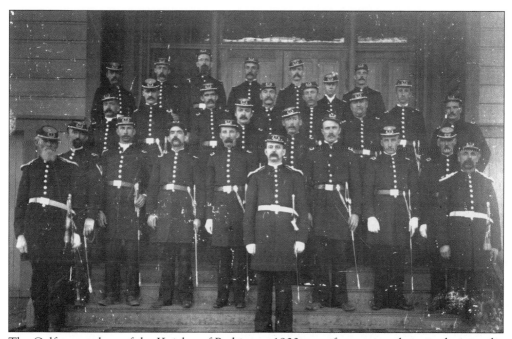

The Colfax members of the Knights of Pythias, c. 1900, pose for a group photo in their regalia with swords at attention. The fraternal order of the Knights of Pythias, founded in 1864, would host balls, help the community, and always worked to promote peace.

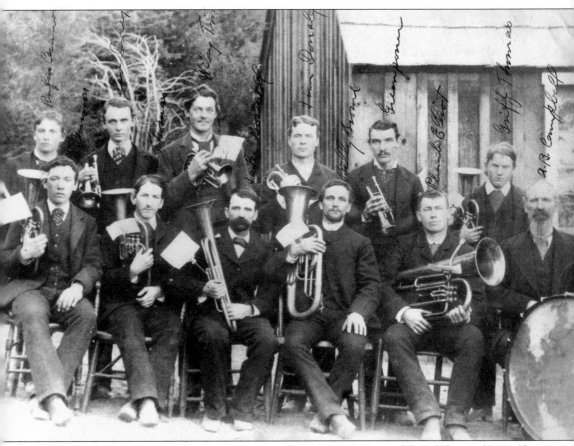

The Damascus Brass Band sat for this group photo in 1885. Pictured from left to right are (front row) R. Cannon, W. Thomas, Jake Boswell, Billy Brome, Plumb Elliot, and A.B. Campbell; (back row) Rufus Cameron, Leo Dorer, Wiley Tiner, Jim Donald, Henry Greenbower, and Griff Thomas. Bands were a very popular form of entertainment for the miners. Carrie Williams recorded her feelings about her husband's involvement in a band in 1858:

Dec. 2—Wallace came home this evening with another tooting machine and said the he had told the Union Brass Band Company that he would occasionally take a part with them, which piece of news I did not fancy at all.

Sunday 12—Wallace sat up all last night until half after one working on his mouthpiece; I was so vexed with him about it.

Tuesday 14—Wallace did not come last night until after one. He said the band of brass horns went out serenading. I suppose all the Bridgets in that neighborhood were beautifully tooted at, from his description.

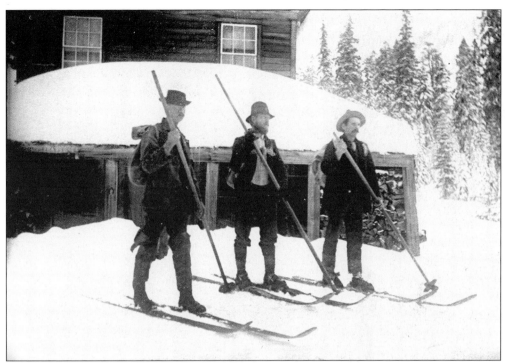

Three men set out on their skis at Secret Spring House. The man in the middle is Ben Buchman.

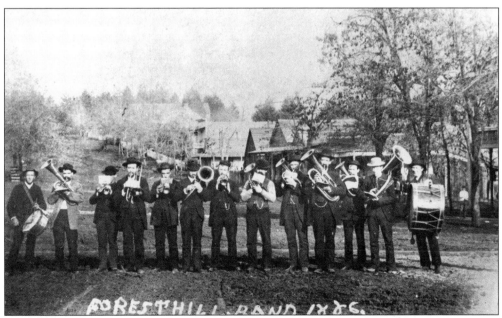

Towns from all over Placer County hired members of the Foresthill Band of 1886 to play at their dances and celebrations. Fourth of July and Christmas were the most popular holidays, but very little cause was needed for a celebration.

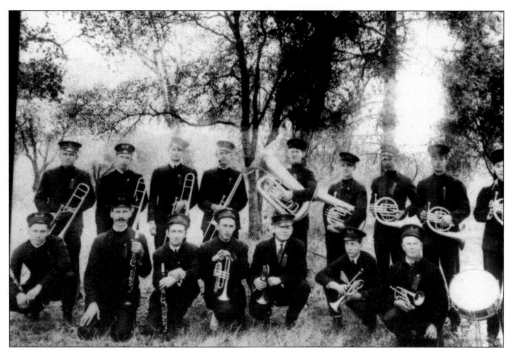

The Auburn Concert Band was just one of many bands formed by the men of Placer County. Pictured from left to right are (front row) Joe Jacobson, Ernest Jones, ? Finley, Emery Logan, Alba Swesey, Chester Black, and Harry Branch; (back row) Louis Logan, Chester Bullard, John Cook, Arial Muwet, George Johnson, Wilbur White, Homer Hawkins, Keith Douglas, Frank Dake, and Victor Johnson.

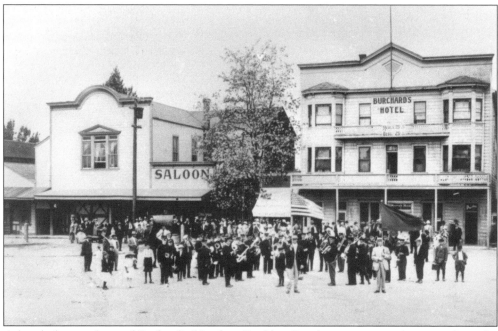

A band plays in front of Buchard's Hotel in Rocklin. Bands were a great diversion from the trials and tribulations facing many newcomers.

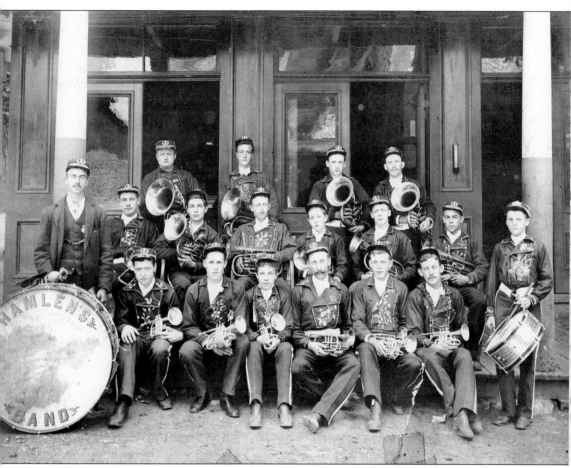

Cal Hamlen ran a butcher shop, taught music in Dutch Flat, and also led a band. Pictured from left to right are (front row) Art Nicholls, Frank Lakamp, Walley Nicholls, Cal Hamlen, George Kopp, Jay Waggoner, and Willie Bellows; (middle row) Fred Hudson, Phil Niles, Frank Shaffer, Henry Olsen, Louis Faller, Glen Wedgewood, and Nelson Waggoner; (back row) Andy Baker, George Grey, Ed Grey, and George Johnson. On the left, a little girl who might be Edith Jones or Lois Kempster peeks from around the corner.

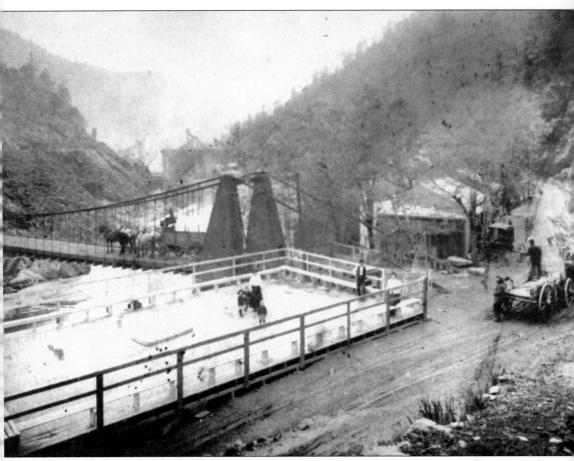

The bridge at the North Fork of the American River is a wonderful place for dancing. A few brave souls stand in the middle of the dance floor. In the early days of Placer County, very little was needed to encourage dancing. Leonard Davis, local historian, recalled a story about the discovery of part of a lady's hat. This evidence that a woman, a rare commodity at that time, may have passed through caused so much excitement and joy that it was immediately decided to have a ball on the spot. Three hundred miners dressing to the nines and carrying liquid courage came together to honor the hat. A stick five feet high was driven into the spot of discovery with the hat of tribute placed on top, and a blanket wrapped around the pole. To the miners, who had not seen a woman in ages, their beloved creation resembled a female. The ball lasted for two days and this place of celebration eventually became the town of Auburn.

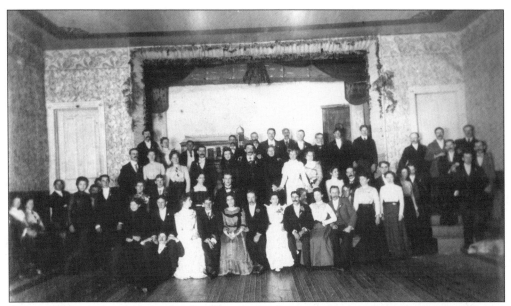

A group takes a break from the Saturday night dance at the hotel run by William Rea in Foresthill. William Rea was born in Canada in 1833 but was raised in Maine. Using the Nicaragua route, Rea came to California in 1854, traveling on to Forest Hill in 1855, and started a sawmill business. In 1875, he leased the Forest House, a large two-story hotel with front double porches.

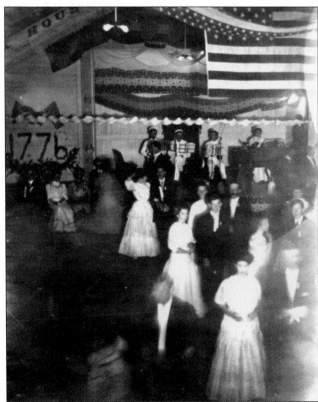

The Ferguson's Opera House plays host to the annual Fourth of July celebrations in Dutch Flat. Revelers enjoy a ball on the opera house dance floor.

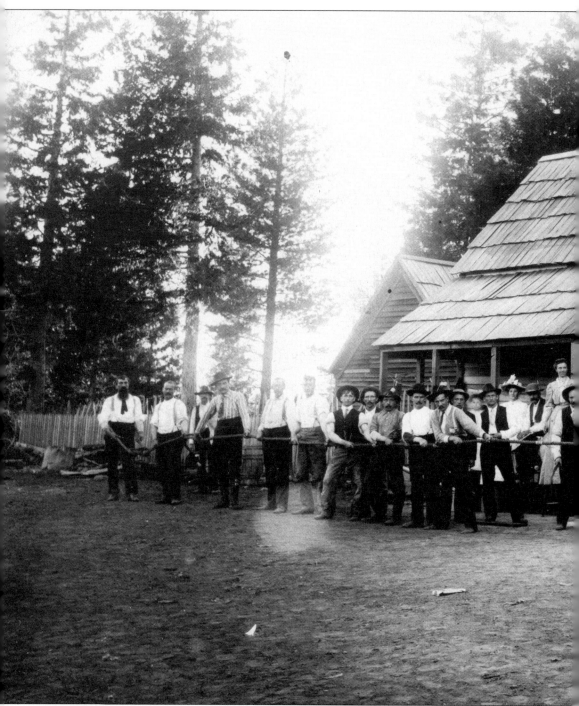

The people of Last Chance celebrate the Fourth of July in 1895 with a good, old-fashioned tug-o-war. Due to the lack of gold, this was probably the last chance for celebration before the end of the century in the little town. There are many stories as to how Last Chance was named. Some say it was named when a hungry miner shot down a grouse with his last bullet, while others claim it was when two miners were near the brink of starvation and one miner

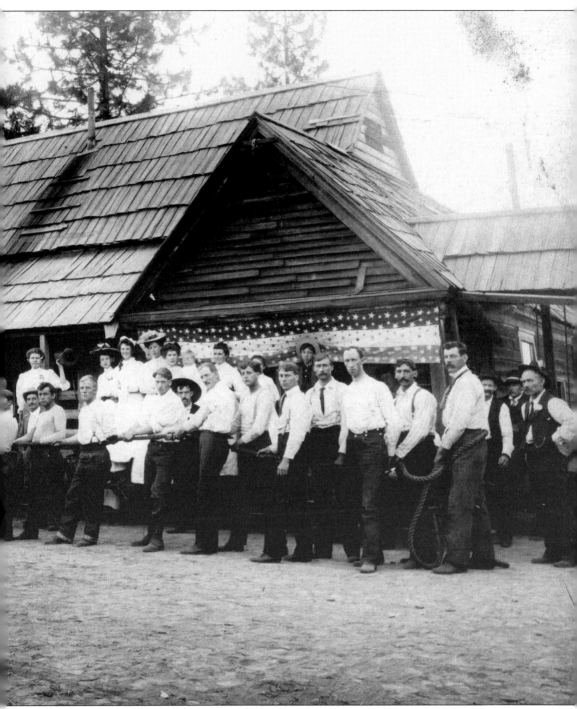

asked for a last chance to kill a deer with his one remaining bullet (he returned triumphant). Still others assert it may have been the constant threat of starvation, the harsh winters, and the people who held out under these arduous conditions hoping to strike it rich. The town had many last chances in its 100 years of existence, but it finally died in the 1970s when the last of the hydraulic mining ceased.

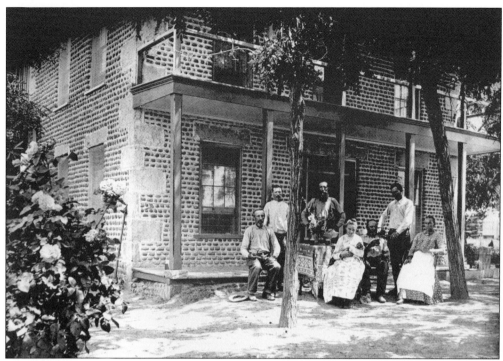

A family gathers for a picnic at the Old Cobblestone Ranch at the Lee Mine.

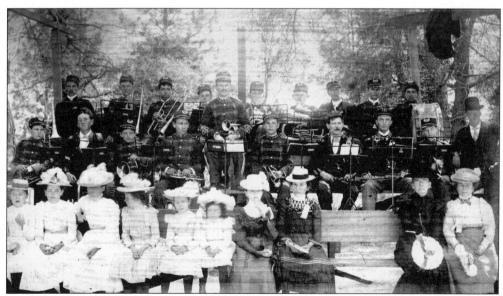

Auburnites enjoy the pioneer picnic at the race track in Auburn. Early settlers and pioneers of Placer County attended the picnic and enjoyed dancing, music, and food.

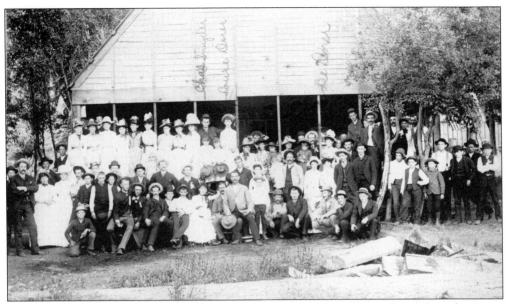

The Dorer family and friends gather together for a picnic at Main Top, located on the Forest Hill Divide. Main Top served as a way station for people heading up to the mines.

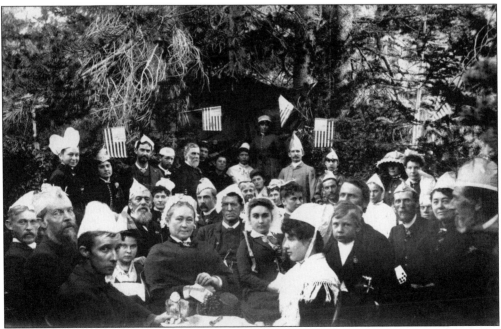

Cisco residents gather together on August 22, 1885, to celebrate at what the townsfolk called "Camp Comfort." Cisco, named after John J. Cisco, the treasurer of the Central Pacific Railroad, was a jumping-off point for miners headed to the silver mines in Nevada. Cisco was also a resort area for the people of the San Francisco Bay area. Many would spend the summer at Cisco, perhaps joining "Camp Comfort."

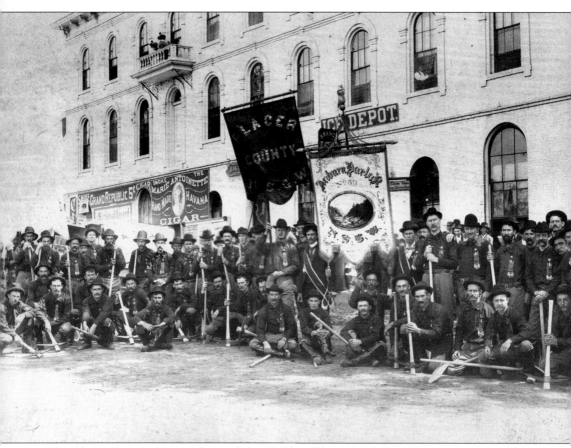

The Placer County Native Sons of the Golden West traveled to Sacramento to celebrate California's Admission Day in 1895. The *Record-Union* stated

Then came Auburn Parlor, 59, with excellent band, and it was, beyond doubt, one of the features of the parade. Its members were dressed uniformly in red flannel shirts, blue overalls and no suspenders, while over the shoulders of the men in the right hand line were thrown proverbial picks, the men on the other side carrying shovels. No need to tell visitors that they were from a mining district, even if they did wear red shirts, which very few miners ever did, but which is one of those revered visions that the rising generation prefer not to dispel.

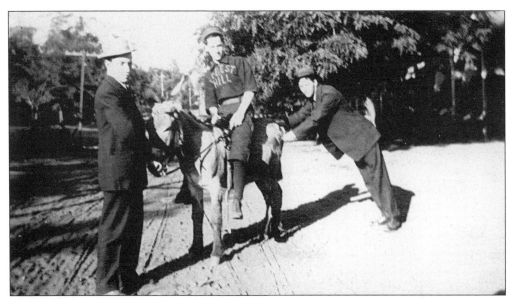

A Forest Hill baseball player rides a donkey that needs a little prodding by some admiring fans. The baseball games of these times had very high scores. The Auburn team beat Colfax 52 to 16 in 1875.

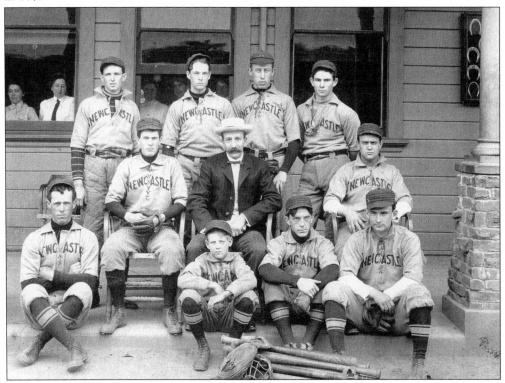

The Newcastle baseball team poses for their team picture. In the late 1800s, towns like Newcastle, Forest Hill, Iowa Hill, Michigan Bluff, Loomis, and Rocklin formed their own teams. One of the most famous players from these teams is Bill James from Iowa Hill. James helped pitch the 1914 Miracle Braves to a World Championship with a 26-7 overall record.

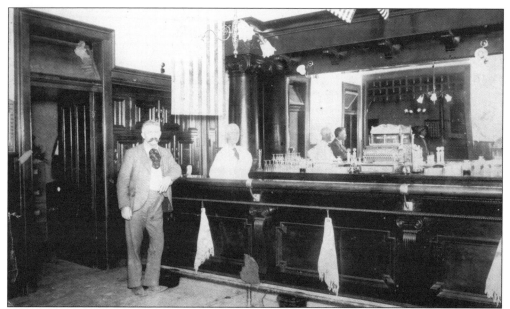

William Conroy stands in front of the bar at the Conroy Hotel. Conroy was the sheriff from 1893 to 1905. The Conroy Hotel had 20 guest rooms, a parlor, a dining room, a kitchen, an office, and a bar with a billiard table.

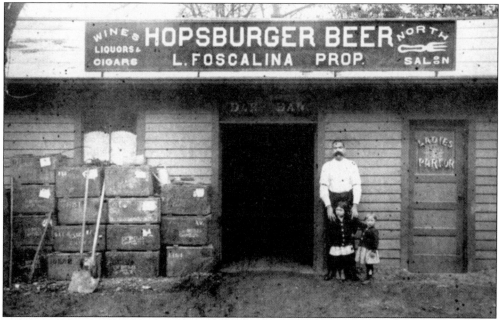

Located by the North Fork Bridge, the North Fork saloon was run by Mr. Fosalina. He proudly served Hopsburger Beer and provided a ladies' parlor. The dance floor near the North Fork of the American River was conveniently located for the saloon patrons. Sam Jarvis recalled: "Among the mines it was the universal custom for all the saloons to give the miners a drink of whisky every morning up to a certain hour. It was called 'Mornings, Mornings.' Many miners went to work but some were always trying to get all they could for nothing and would go from saloon to saloon until they were tottering and could hardly walk to work."

Eight
FACES

Sarah Schmutzler, on the right, sits with her friend in Forest Hill. Sarah's father, Charles Schmutzler, was a miner in Forest Hill in the late 1800s.

John Butler was Placer County sheriff from 1886 to 1890.

Female members of the Atwood and Duffield family gather in the garden. Nathanial Atwood came to Placer County from New York in 1855. He married Lucretia Clark, a woman originally from Ohio who lived with her parents. They had 11 children, and their youngest son, Edgar, married Ammie Duffield. A grandchild of Nathanial and Lucretia also married a Duffield. Atwood Road in Auburn was named after Nathanial Atwood.

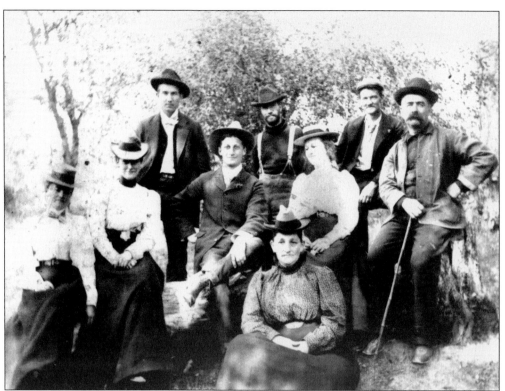

This group of men and women are associated with several different mines. Pictured from left to right are (front row) Mrs. Freeman; (middle row) Kate Deetkin (related to G.F. Deetkin, the superintendent of the Marguerite Mine); Rose Freeman; Leon Greenbaum; unidentified; and Ben Hartley, superintendent of the Zantgraf Mine; (back row) Joe Hamilton and three unidentified.

Dr. Todd worked as a physician, as well as keeping a store and hotel that served as a stop for miners going to and from Stony Bar and Horseshoe Bar. He arrived in Placer County from West Virginia c. 1849 and Todds Valley was named after him. Dr. Todd was related to Mary Todd Lincoln.

Pictured here is Susie Simons of Dutch Flat. There were only 345 females in the county in 1852. There were hardly any single women to be found; according to the local miners, even the plain ones had a chance. However, the divorce rate was extremely high.

The Marguerite Mine, just north of Auburn. was named for a young girl, Marguerite, pictured here sitting on her horse. In 1894, a newspaper reported that the mine was producing good ore and would begin crushing shortly. The *Placer Herald* reported in 1895 that "the Marguerite Mining Company, composed of wealthy and influential German citizens of San Francisco, purchased the old Salsig claim adjoining the Marguerite property. Their energy has created an awakening in mining properties in this locality." Later reports claim the mine quickly petered out.

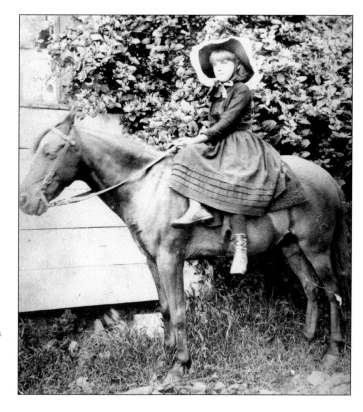

Grace Beaquette Ramsdale and her husband are shown here on their wedding day. During the late 1800s, women followed a strict code of etiquette for courtship and marriage. At dances a woman never had more than two dances with the same man. Engagements were very short and the bride was not to be seen in public after the invitations were sent out, usually 10 days before the wedding.

An angelic-looking young Adolph Weber sits for a photograph at the turn of the century. In 1904, Adolph would become infamous for robbing the Placer County Bank on Commercial Street in Auburn. He went on to kill his mother, father, brother, and sister, as well as set the family's home on fire. He was hung for his crimes on September 27, 1906.

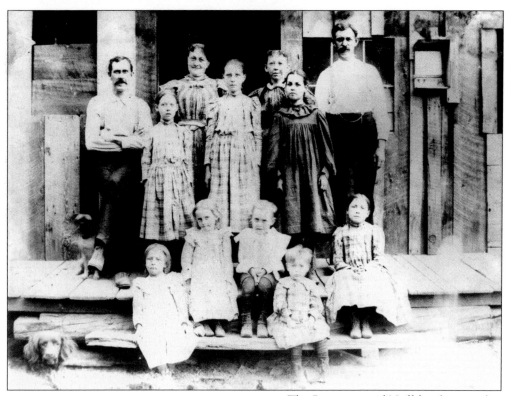

The Peterman and Neff families stand at the entrance to the Last Chance Mine. Pictured from left to right are (first row) Ethel Peterman and Linus Peterman; (second row) Lulu Peterman, Clarence Neff, and Flora Peterman; (third row) Faye Peterman, Sadie Peterman, and unidentified; (fourth row) Frank Neff, Laura Neff, Elvira Peterman, and L.C. Peterman.

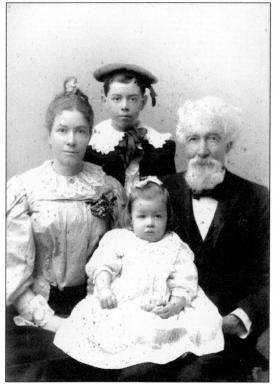

Judge Benjamin Franklin Myres sits with his granddaughter Florence Michael and her sons, Ben and John. Myres was one of the first judges in Placer County. Before Myres became a judge he practiced law in Placer County. It is said that in 1852 he got in a fistfight in court with another lawyer. The case was allowed to proceed after the fight was finished.

Capt. Jesse Ives Fitch was in Company B, 4th Regiment, Infantry for the Union Army. He later became superior judge of Placer County under Governor Pacheco from 1872 to 1880.

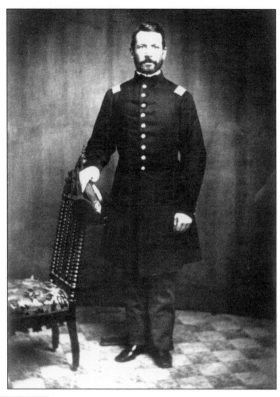

Richard Dorer came to Placer County in 1853 with his brother Leopold. They settled in Humbug Canyon and made a tidy profit from their mining. Richard returned to his native New York where he married Anna Develey. The newlyweds returned to Humbug Canyon and set up a homestead in the area.

Harriet Bisbee McCann and Rose Walsh have their picture taken. The two young ladies were descendants of early Placer County pioneers. James Walsh came from Ireland to try his hand at mining. Like most miners, Walsh was suited for another profession—he set up a boot shop in Auburn.

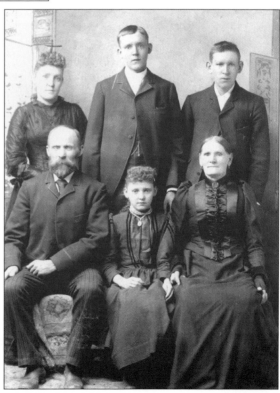

J.H. Holt and family pose for a picture while living in Sunny South.

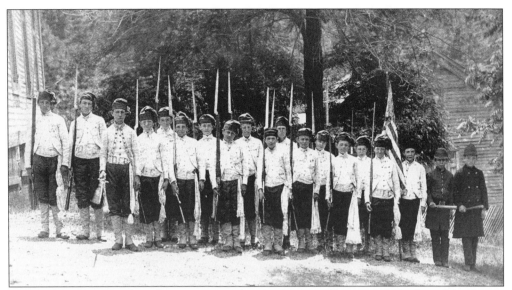

The Dutch Flat School Cadets come together for Memorial Day in 1890. Gen. John Logan officially proclaimed Memorial Day (originally called Decoration Day) in 1868, and it was observed on May 30 of that year. The graves of Union and Confederate soldiers in Arlington were decorated with flowers on Memorial Day. Except in the South, Memorial Day was a nationally recognized holiday by 1890.

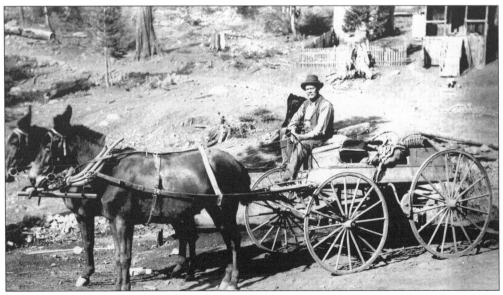

John Hutchinson, from Kenton County, Kentucky, manages his mule team. The mule team was an important workforce in the mining industry. Once the goods had been delivered by wagon or, eventually, railroad, the mule team would pack up the items to be delivered to far off destinations. Towns far up in the foothills would wait for months for the mule team to deliver their supplies.

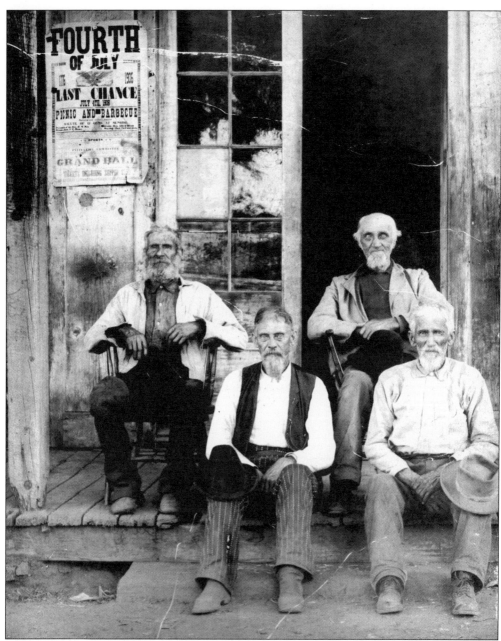

At the turn of the century, four old miners gather in front of a store in Last Chance to reminisce about the days of yore. Pictured from left to right are (front row) John Ray and Andy Hauk; (back row) Barney Cavanaugh and Bill Anderson. One of their favorite subjects was Barney Cavanaugh's lack of luck with women. He once asked a woman to marry him and she asked to be excused. He said, "Me darn fool," and excused her. Cavanaugh also had a tendency to drink too much at a dance and declare he was left-footed with both feet. If a woman would ask him for a song, he would say, "I'll give you the words, but you will have to go outside for the air." The men of Last Chance sometimes did without women; sometimes they would have stag balls and dance with each other.

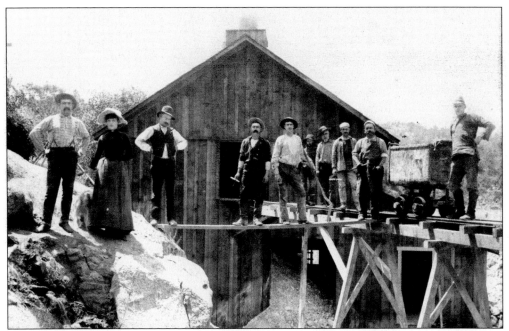

An old mining operation somewhere in Placer or El Dorado County serves as the backdrop for this group picture. Originally owned by Pearl Atwood Duffield, the photograph might include some of her family. Notice that some of the miners are carrying miner's candlesticks. These candles had a sharp point so that miners could stick them in the walls as they worked down the tunnel.

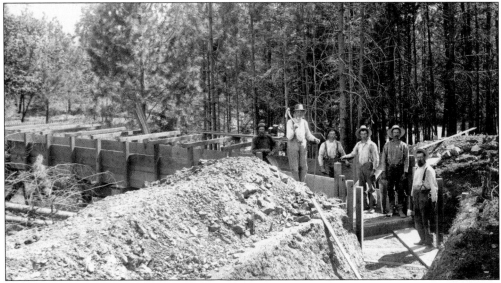

Six miners build a flume to carry water to the You Bet Mine near Secret Town. Pictured from left to right are unidentified, Grandpa Hayford, Bob Linder, the foreman, Val Norton, and Frank Godding. Grandpa Hayford was 90 years old when this picture was taken.

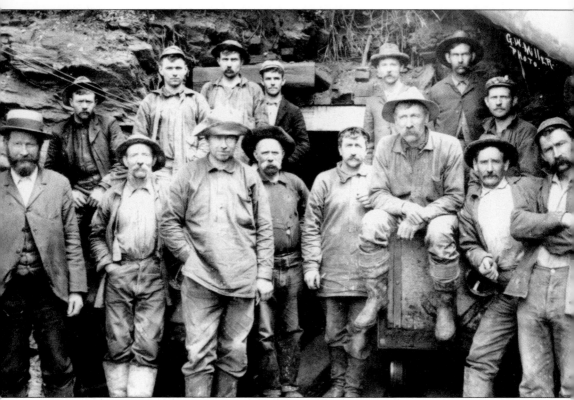

Just looking into the eyes of these men standing in front of a mineshaft, one can see life was extremely hard and many did not survive their first year. The following is just one of many letters that were written to the family members left behind:

Mrs. Williams,

If this short letter ever finds you, you will doubtlys think it is strange that an entire stranger should address you from this distant state, and indeed sorry am I that a gainful sense of duty prompts me thus to do.

I have been acquainted with your husband Henry Williams about eight years. He resided at the Horse Shoe Bar. He was a man beloved and respected by all. He was an industrious hard-working man, but, unfortunately, his efforts were never blessed with much success, and therefore he was rather poor. About four weeks ago he was taken sick, and although at first he did not think it serious, he got worse and worse until at last, at about 1 o'clock he expired Saturday Nov. 15th. He did not, as I think expect he was to leave us so soon else he might have told some of his friends about his folks at home. In the forenoon of the 14th, he felt cheerful and hopeful of a recovery, but at about 2 o'clock he was taken with severe spasms which continued till the Lord relieved him of his sufferings, during this time he was either unconscious, to appearance, or he was incapable of articulation, consequently I am unable to communicate any desire or thought of his in reference to the ones at home.

Most sadly and respectfully,

B.S. Smith

Two men lean against the hydraulic monitor named "Governor Markham," after the governor of California from 1891 to 1895. Markham was California's 18th governor.

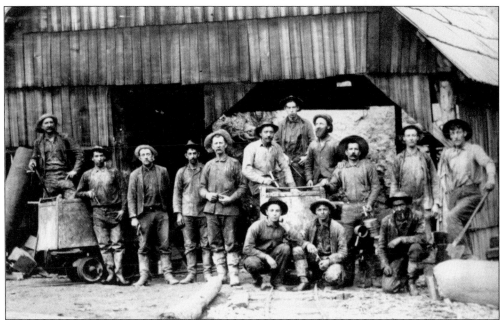

A group of miners are pictured here standing outside Old Herman Mine. Miners faced many hardships and often warned their families back home not to join them in this "desolate place."

Three men surround an ore car in Hidden Treasure Mine. The Hidden Treasure Mine headquarters was located in Bullion, then in Sunny South. When the mine was closed down, both Sunny South and Bullion faded away. Notice the man in front holding the carbide lamp. The carbide lamp had two chambers. The lower chamber contained cubes of carbide; a small amount could keep a miner's lamp lit all day. The upper chamber was filled with water. With the turn of a knob, the water was released to the lower chamber, forming a gas that could be lit by a flint starter or match. A shiny reflector near the flame improved the light.

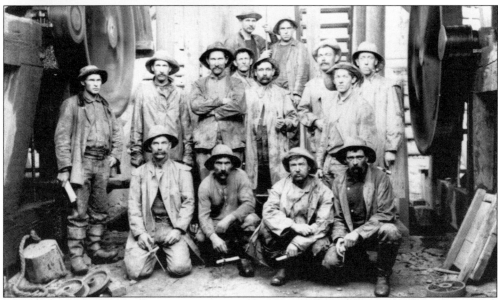

Miners stand between two stamp mills. With the day-to-day rigmarole of work, miners needed a way to blow off some steam. Sam Jarvis recalled a time when someone had a laugh at his expense: during a dance held near Last Chance, Jarvis reached for his handkerchief in his pocket. As he pulled out his hankie, five water snakes also came out of his pocket. They dropped to the dance floor and slithered around. Ladies and gentlemen screamed and shouted as they moved as fast as possible away from the creatures. Holding up a $20 gold piece, Jarvis said, "Whoever can tell me who put the damn snakes in my pocket can have this." The owner of the dance floor offered two more $20 gold pieces, raising the reward to $60. No one came forward to claim the money and the jokester was never found.

Nine

THE CHINESE

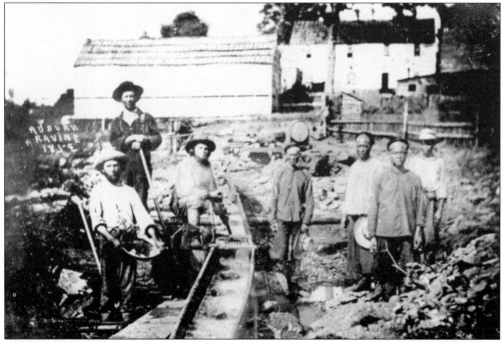

Chinese and white miners work at the head of Auburn Ravine in 1852. At the time this picture was taken, the Chinese were the single largest ethnic group in Placer County. The 1852 census listed 3,019 Chinese out of 10,784 total county residents. The totals may have actually been higher, but anti-Chinese sentiment caused many to hide from census takers out of fear. White miners resented the Chinese miners for any success, and the fact that they chose to work and live in their own community increased suspicion.

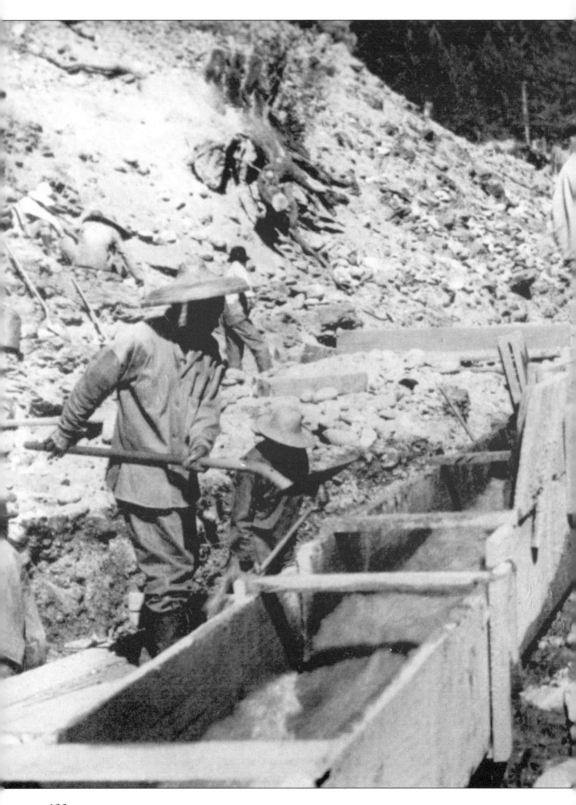

Pictured here are Chinese miners working their own claim. Most Chinese immigrants came from the Kwangtung province. People from this area were under great pressure from wars, political instability, foreign intrusion, and even natural disasters. Once the news of the Gold Rush reached China, the men from the Kwangtung province left their homeland. The journey to California often took three months, and, once arriving in Gum San or Gold Mountain, the traveler would have to pay off his $40 to $60 debt doing hard labor. Once the debt was paid off, the Chinese miner was relegated to reopening abandoned claims using very basic mining tools. There were some reports of success in the local newspapers. In 1856, the *Placer Herald* reported that a Chinese man found a nugget worth $3,300 and "started for China the next morning."

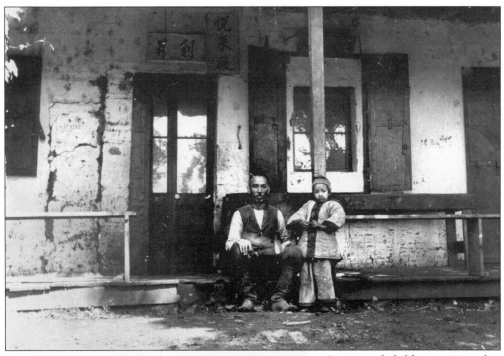

A man and child sit on a porch in Dutch Flat's Chinatown around the turn of the century. At the height of the Gold Rush, Dutch Flat claimed the largest Chinese population of about 800. Because of discriminatory laws and behavior, the number of Chinese decreased to approximately 300 by 1900.

Wearing a Western-style outfit, a baby sits for a studio portrait.

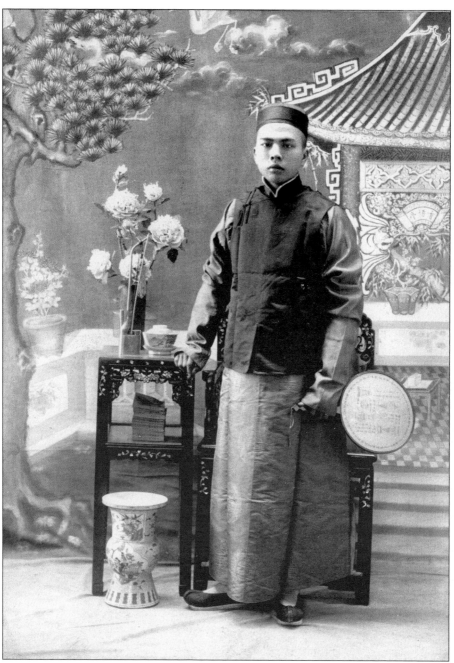

San Francisco photographer W.F. Song took this studio portrait of M.W. Quong. The Auburn Chinese Cemetery was under the stewardship of the Quong family for a very long time. They helped families maintain the burial traditions of China. The deceased was originally buried in the Chinese Cemetery, but after a period of time, the remains would be returned to China. With the help from the Quongs, families of the deceased would disinter the body and pack the bones in a hermetically sealed tin. The tin would travel to San Francisco before taking a steamship back in China. Chinese were usually forbidden to bury their dead in white cemeteries and most of the time had to maintain a small cemetery outside of town.

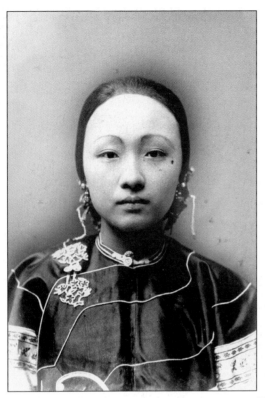

A young, unidentified woman has her picture taken in traditional Chinese clothing. Having tiny feet that resembled golden lotuses was part of traditional dress for upper class Chinese women. The desirable length was three inches, although this was a rare achievement. Young girls from wealthy families would have their feet bound with bandages of silk or cotton to force the small toes together and under the sole and the big toe above the foot. This practice made the women completely dependent on others, and her feet showed that her family was wealthy and could afford her inability to walk or work. The few Chinese women who came to the mining camps, however, endured much hard work.

Bird and Cook, photographers of Placerville, Auburn, and Willows took this studio portrait of Kee Chinn. With only 500 of the 5,000 labor positions filled, the Central Pacific Railroad recruited heavily from the Chinese community. In 1865, only 50 Chinese from Auburn joined; however, by the end of 1865, over 3,000 Chinese were giving their sweat—and some their lives—to the transcontinental railroad.

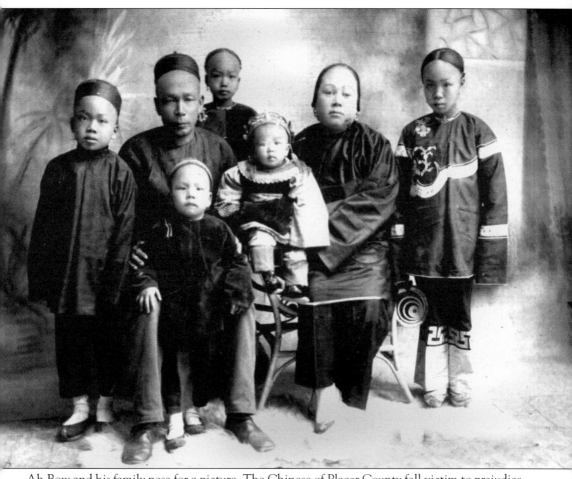

Ah Bow and his family pose for a picture. The Chinese of Placer County fell victim to prejudice and violence. One of the most infamous examples of this behavior was the mass expulsion of Chinese in Rocklin and Roseville in 1877. Ah Sam was accused of a triple homicide in Auburn, which led to anti-Chinese rioting. A fire was started in Rocklin's Chinatown, and 25 buildings were burned. White citizens of Rocklin and Roseville banded together and drove the Chinese out of their communities. Auburn and Ophir formed anti-Chinese clubs, and the newspapers were constantly reporting that the Chinese were stealing chickens. The 1870s were a time of terrible unrest for Placer County Chinese.

China Mary lived in Dutch Flat and was over 100 years old when this picture was taken. Dutch Flat and Auburn had the largest Chinatowns in Placer County, but one existed in nearly every mining town. According to assessment rolls from 1857, the Chinese could be found selling goods in Michigan Bluff, Auburn (on China Street), Iowa Hill, Michigan Fork, White's Ranch, Rattlesnake Bar, Murderer's Bar, Poverty Bar, Smith's Bar, Horseshoe Bar, and Ford's Bar.

Pictured below, from left to right, c. 1890, are Lil Ramage and Clara Lee Fitch sitting outside a building located at the Mammoth Bar Mine on the America River while a Chinese cook stands in the doorway.

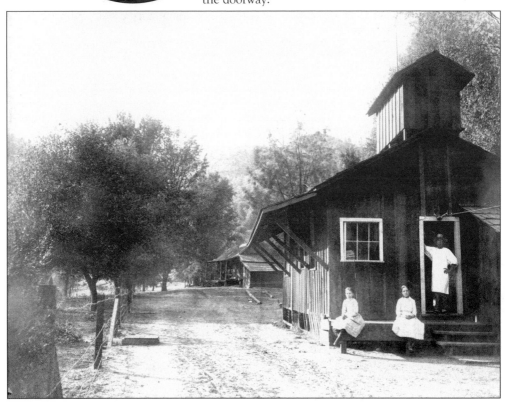

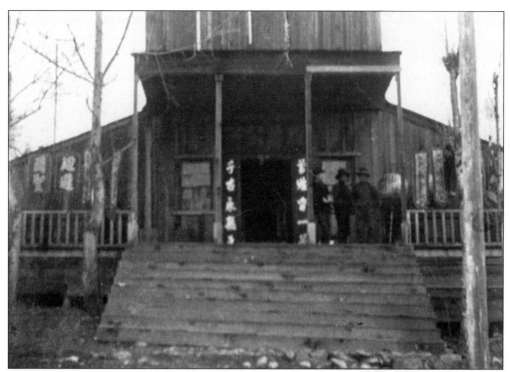

This joss house was located in Dutch Flat. A joss house played many roles in the Chinese community. It was a place of worship, a schoolhouse, a community room, and a place to welcome and help newcomers.

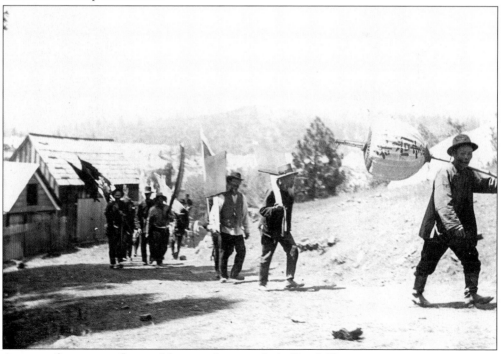

A group of men carry flags and lanterns in a parade in Dutch Flat.

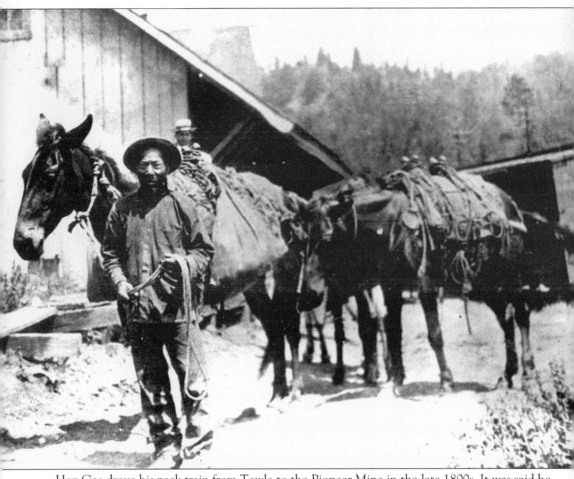

Hop Gee drove his pack train from Towle to the Pioneer Mine in the late 1800s. It was said he was over 70 when this picture was taken. The Chinese were subjected to the foreign miners tax, passed in 1850, charging a monthly fee to mine. In the beginning, Placer County, unlike other counties, made all foreign miners pay the tax. A version of this law focusing primarily on the Chinese was passed the following year. The tax added greatly to the county's and state's revenue, contributing thousands every year. For example, from June 2, 1855, to June 2, 1856, the tax collector raised $40,691.52, mostly from Chinese. The Chinese Exclusion Act of 1882 virtually sealed off immigration from China until it was repealed in 1943.